New Japanese Photography

The Museum of Modern Art New York

Distributed by New York Graphic Society Ltd. Greenwich, Connecticut

New Japanese Photography

ニュー ジャパニーズ フォトグラフィー

Edited by John Szarkowski and Shoji Yamagishi

This book and the exhibition it
accompanies have been made
possible by the generous assistance
and support of the National Endow-
ment for the Arts in Washington,
D.C., a Federal agency, and of
SCM Corporation.

The Museum of Modern Art
11 West 53 Street
New York, New York 10019
Printed in the United States
of America
Designed by James Wageman

Contents

Acknowledgments

John Szarkowski

Shoji Yamagishi

This book and the exhibition on which it is based have been made possible by grants from the National Endowment for the Arts in Washington, D.C., and SCM Corporation. Those who are concerned with photography's contribution to the art of our day are in their debt.

As coeditors of this book, we gratefully acknowledge our indebtedness to the many individuals and organizations who have contributed so generously to it. The preliminary travel and research with which this project began were sponsored by the International Council of The Museum of Modern Art, New York, and supported by the JDR 3rd Fund. Research in Japan was assisted immeasurably by *Camera Mainichi,* the Mainichi Newspapers, who made their library and staff available in a spirit of generous cooperation. Yasuhiro Ishimoto was enormously helpful as a selfless liaison with the other photographers, and as a translator who understands the photographer's special language. Toshio Saitoh and Doi Inc. produced most of the exhibition prints, according to the demanding personal standards of the photographers. Harold Jones of Light Gallery generously lent six photographs by Eikoh Hosoe. Mineo Mizukami solved the difficult problems of written translations, and Kyoko Yamagishi did much necessary and important research. Marjorie Munsterberg contributed invaluable editorial assistance and worked effectively on many problems involving the organization and installation of the exhibition.

Finally, and most importantly, we would like to thank the photographers themselves, whose cooperation, generosity, and interest have made this project a rewarding adventure for those who have contributed to it.

Introduction

John Szarkowski

The progressive homogenization of the world during the twentieth century has by now made the national art exhibition a device of greatly diminished utility. This is not to say that national differences do not exist. An expert presumably could distinguish, without labels, a survey of contemporary Australian painting, for example, from a comparable exhibition in Stockholm, but even this expertise might serve to identify a distinction without a significant difference.

The disappearance of discrete local traditions has been hastened by two factors. First, the formal and technical vocabulary of the arts has been universalized by photomechanical reproduction: what comes new from an artist today will, if interesting, be the common property of the whole world next year, though perhaps in a form slightly damaged in transit. Perhaps even more important than the universal sharing of forms and techniques is the fact that the quality of experience of most of the world's people has become increasingly similar. Not merely our food, clothes, houses, automobiles, and amusements, but the rhythms of our lives and the nature of our relationships to our fellows, and to our increasingly self-effacing gods, have become more and more nearly alike. It is doubtless possible to prove that this is not necessarily a bad thing—that it merely changes the scale on which we still recognize and delight in the spice of variety. However, we are speaking here not of the demise or survival of variety, but of its survival on the basis of geographic patterns. On this ground it seems clear that the significant divisions into which contemporary artistic expression falls are generally not regional ones.

One might expect that this generalization would be especially true in the case of photography. It has been said (repeatedly) that photography is a universal language. In fact, however, photography is merely a universal technique. To speak of it as a language is to ignore the fact that its meanings (unlike those of Greek, or algebra, for example) cannot be translated with any acceptable degree of precision into *other* languages. It is surely clear also that only in its most pedestrian and utilitarian functions does photography approach universality of meaning.

Most of the meanings of any picture reside in its relationships to countless other and earlier pictures— to tradition. In the case of photography this tradition is so short, complex, and chaotic, containing so many rapid changes and apparent contradictions, that even the best of photographers—who are generally more alert than anyone else to the content of this tradition—comprehend it only intuitively and fitfully. As practiced by its most talented and original workers, photography is not the lingua franca of our age, but perhaps the most underground of all the arts. Thus it is still possible for exceptional local circumstances to produce special perspectives on the question of the medium's possibilities.

The preceding paragraphs attempt to explain the possibly surprising but undeniable fact that there has arisen in recent years a distinctively Japanese photography. Unlike Shoji Yamagishi, this writer is in no sense an expert on the history or meaning of this development; the following comments should therefore be taken only as the tentative suggestions of an admiring amateur.

In retrospect it seems possible that the ferment in Japanese photography during the past two decades has been caused by three factors: the patent bankruptcy of the prewar tradition of photographic pictorialism, the national fascination with photography as a technique, and the stunning speed with which the character of Japanese life itself has been transformed.

Both in form and subject matter, "serious" prewar Japanese photography (meaning that work done with aesthetic intention) imitated the aspect of the traditional pictorial arts. Subject matter was typically pastoral, lyric, thoroughly familiar, and philosophically acceptable. Visually the pictures were constructed of neat and simple graphic patterns, favoring a strong planarity and a submerging of specific detail. Even contemporary subjects were seen from a safe psychological distance, which bathed them in a mist of contemplative noninvolvement. Ironically, these photographs were probably imitations of the work of Western photo pictorialists, who had themselves learned most of what they knew from a third-hand Japonisme. After the war the inadequacy of this tradition would have been evident to any serious photographer.

The popular postwar enthusiasm for photography in Japan is a very different matter, for it seems to concern itself with no aesthetic theory or attitude, but with an almost undifferentiated love of the process itself, and a fascination with almost anything that it produces. It may be relevant that Japanese photographers are from time to time accorded an intense, unpredictable, and generally fleeting fame, similar to that which in the United States was once visited upon movie starlets. Having no clearly apparent qualitative standards, this enthusiasm is remarkably open-minded, and rejects nothing out of hand.

All countries have changed greatly in the past quarter-century, but perhaps none has changed so radically or with such dizzying speed as Japan. The character of this change need not be recounted here, and this writer is not competent to balance what has been gained against what lost. What should be pointed out here is simply that these issues are the substance of the photographs in this book. On their evidence, it would seem that photography is ideally suited to deal with the definition of such revolutionary change, because it is flexible, intuitive, autographic, fast, cheap, tentative, and perhaps, in some sense not yet understood, accurate.

The quality most central to recent Japanese photography is its concern for the description of immediate experience: most of these pictures impress us not as a comment on experience, or as a reconstruction of it into something more stable and lasting, but as an apparent surrogate for experience itself, put down with a surely intentional lack of reflection. In the visual arts, it would be difficult to name an artist who more closely approaches the ideals of automatic writing than Daidoh Moriyama, and even the highly systematized and conceptualized work of Ken Ohara seems designed to exclude, rather than reinforce, conscious critical or aesthetic interpretation.

A suggestion of this new spirit is present in Ken Domon's shattering series on the survivors of Hiroshima (1958), which was done with the same reserve and apparently disinterested objectivity as his classic documentation of traditional Japanese art—the chief and continuing work of his life. But the pivotal figure of recent Japanese photography is Shomei Tomatsu, whose work has defined the iconography, style, and method against which younger Japanese photographers have measured their own identities.

Tomatsu's early work was conceived within the framework of traditional photojournalism; the slice of time that such pictures recorded was selected and presented in a way to suggest that it held a special narrative significance as part of a larger, coherent story. As Tomatsu matured, his pictures described data that claimed less and less inherently "newsworthy" significance; their nominal subject became more ordinary, often even trivial, while the pictures themselves became sharper and richer records of Tomatsu's intuitive response to the experience of life itself. Tomatsu's gradual rejection of the concept of journalistic illustration parallels a similar change in spirit among many talented photographers throughout the world during the same period. However, the highly individual character and meaning of Tomatsu's work cannot be explained in negative terms: it was not the rejection of traditional journalism but the acceptance of a larger and more difficult problem that defines Tomatsu's identity as a photographer. This problem was perhaps the rediscovery and restatement, in contemporary terms, of a specifically Japanese sensibility.

The suggestion of the nihilistic that exists in Tomatsu's work has been made boldly and effectively explicit by Moriyama. Indeed, what is intuition in Tomatsu becomes an almost mystical obscurantism in Moriyama, and what in the older man is a sense of tragedy becomes in the younger an occult taste for the dark and the frightening.

The very force and persuasiveness of Moriyama's work may have persuaded still younger Japanese photographers to react against it, to attempt an expression that might regain balance and control, and a voice for the restraining role of intellect. In the work of these photographers—Akiyama, Ohara, Tamura, and Jumonji—the functions of wit, objectivity, and reflection seem to have again entered the photographer's definition of his role.

The final effect of recent Japanese photography cannot today be guessed, either in terms of its continued development as a discrete local expression or in terms of its influence on the world's photographic community. One can assume that photographers of other countries will appropriate—and domesticate for their own uses—that which is of greatest value to them. And one can hope Japanese photographers will continue to explore the exhilarating possibility that—in the arts at least—there is after all more than one world.

Shoji Yamagishi

The exhibition on which this book is based is the first attempt to present an extensive survey of contemporary Japanese photography outside of Japan.

Contemporary Japanese photographers have values which seem distinct from those of the photographers of the West. They are, for example, not particularly interested in the quality of the finished print. In this respect it might be said that they are rather unsophisticated. Because Japan does not have art museums with either the experience or the equipment necessary to handle photographic exhibitions, Japanese photographers have only a limited opportunity to present their original prints to the public. (Nor do they have the opportunity to sell their pictures to public or private collections.) As a result, art museums in Japan have not been recognized as established authorities in the community of photography. On the other hand, there are a few young photographers who simply have not acquired the skill of making a finished print of superior quality, and ironically, in this respect, a few young photographers have cast doubt on conservative authority and established values—which in reality do not apply in Japan so far as photography is concerned. Some photographers even claim that devotion to the quality of the finished print merely restricts the actuality of photographic expression.

Japanese photographers usually complete a project in book form, joining in series a number of photographs related by a common subject, theme, or idea. The full value or impact of such work cannot be understood if individual pictures are isolated from the series for exhibition on the walls of a museum. To do this deprives the photographs of their intended relationship to those which preceded or followed them in the series. In addition, the photographs were originally made to be reproduced in print form, in books and magazines, and not to be displayed as part of an exhibition. It is, therefore, almost impossible to present a precise and objective picture of the complexities of Japanese photography in an exhibition format.

With this in mind, I was originally rather skeptical of the true value or significance of displaying these works out of the context for which they were created. In addition, Japanese photography is so extensive, diverse, and mobile that it is almost impossible to present an outline of its complexities in a compact format. Even if it were in some way possible, it seems to me that such a comprehensive and interpretative display would have little significance today when international exchanges of art and culture are so active. I overcame my hesitation and my doubts, however, because of the following words of John Szarkowski, which kept coming to my mind: Let us admit to each of the photographers that this is what we think his work means in relationship to the question, What is photography? In view of this basic attitude, I feel that the concept of this exhibition cannot be thought dogmatic.

"New Japanese Photography" is organized as a series of one-man shows which identify the central concerns of each of the fifteen photographers. It was not our intention to make a systematic condensation of the careers of these photographers. It is my hope that this exhibition will serve as a basic step forward in answering the traditional and yet contemporary question, What is photography?

Recently, photography has shown a marked departure from the conscious pursuit of aesthetic expression, and has won recognition as a medium that communicates the photographer's direct involvement with his subject and his own values. In this exhibition we have tried to answer the question: How does Japanese photography relate to the contemporary concerns of the entire photographic

community? It was not our aim to present the many features indigenous to Japanese photography as seen through the eyes of the Western world.

The core of this exhibition is clearly expressed by the concerns of Shomei Tomatsu. He has focused his interest on the course taken by postwar Japan, beginning with the occupation by the Allied Forces, which the young Tomatsu described as "a strange reality that was thrust upon us." It is apparent that his photographs are not an objective record of what happened in Japan during this period. Personal experiences are felt and remembered only by those who have experienced them. A talented artist, however, must be able to isolate such experiences and translate them into an objective form that transcends subjectivity and makes communication possible.

The first portion of this book consists of photographs that deal with the following concerns: a reappraisal of Japan's traditional values (Ken Domon and Yasuhiro Ishimoto); a requiem to those who dedicated their youth to World War II (Kikuji Kawada); observations on the history of Western culture (Ikko); and a confrontation of new attitudes toward sex (Eikoh Hosoe). The photographers belonging to the next generation (Masahisa Fukase, Masatoshi Naitoh, Tetsuya Ichimura, and Hiromi Tsuchida) search for an artistic expression of the unlimited richness of everyday life in contemporary Japan. Facing the collapse of the traditional family system and the devastation of a human environment, they also focus on the more demonic aspects of the world, working on such atavistic subjects as traditional religion and the unsophistication and the eroticism of the Japanese. With his energy and creativity, Daidoh Moriyama confronts the conflict between sentimental self-contradiction and violent self-destruction. We find in the photographs of Ryoji Akiyama a youthful optimism that marks a turning point in this exhibition toward a brighter side. The young photographers who follow Akiyama (Ken Ohara, Shigeru Tamura, and Bishin Jumonji) clearly demonstrate that photography is a kind of consciousness that can be shared by everyone in his daily life, rather than simply an expression of one's own personality or identity.

Many of the essentials of modern photography were learned in the postwar period from Yasuhiro Ishimoto, who brought them from the United States when he returned to Japan. Although it might have been possible to learn the philosophy and techniques of modern photography from someone else, I would like to make clear that without Ishimoto we would never have achieved today's photography.

The history of photography in Japan is different from that of other expressive arts in that it originated in the West and reached Japan shortly after its invention. Japanese photography has borne fruit through a century of cross-fertilization and has now taken root in the soil of traditional Japanese culture. It has been our concern in this exhibition to discover whether or not the fruit contains seeds of universality.

まえがき

ジョン・シャーカフスキー

今日では世界各国の文化の均質化が進み、その結果ある国名を冠した美術展は、美術展としての価値がいちじるしく減少してしまった。だからといって、国ごとの特徴が存在しなくなったといおうとしているのではない。たとえばそのようなタイトルがついていなくとも、現代オーストラリア絵画展と現代スウェーデン絵画展とを見分けることは、専門家ならば可能であろう。しかし専門家でなければ区別がつかないということは、その差が大きな意味をもつものではないことを示している。

それぞれの地域的な伝統の消滅は、次の二つの要因によって促進された。その一つは美術のフォルムやテクニックが、写真複製によって普遍化されたことである。今日ではひとりのアーチストが生み出したものは、もしそれがひとの興味を引くものであれば、その翌年には世界中で共有されるものとなる。もっともこの新しいフォルムやテクニックは、それが伝達される過程で、たぶんオリジナルな形がそこなわれることにはなるが――。フォルムやテクニックなどが共有されるものだということよりもさらに重要なのは、世界の大部分のひとたちの経験の本質がますます同一化したという事実である。これはたんにわれわれの食物や衣服や住宅や自動車や娯楽が、ますます似たものになったということだけでなく、生活のリズムや他人との関係、ひいてはその存在が顕著でなくなった神とわれわれ人間との関係などが、さらに似たものになったということである。このことは必ずしも悪いことではない――これはわれわれが多様性を見出して、喜びを感じるための基準がそのために変わってきているということにすぎない。しかしここでの問題は、多様性が消滅するのか、それとも生き残るのかではなく、地域的なパターンに基づいた多様性がこれからも存在するかどうかなのだが、すでに現代の芸術表現の主要な分類は、地域的な分類ではないということは明らかだろう。

この画一化の傾向は、とくに写真にあてはまると考えられるかもしれない。写真は共通語である、とこれまで（しばしば）いわれてきた。たしかにもっとも散文的で実利的な機能においては、写真は普遍的な意味をもつ。

しかし事実は、写真はたんに万国共通のテクニックにすぎないのである。写真を言葉としてあつかうのは、写真がもつ意味が（古典ギリシャ語や代数があらわす意味と違って）、容認できる範囲内での正確さで〝他の言葉〟に翻訳することが不可能であるという事実を無視することになる。

ある写真がもつさまざまな意味の大部分は、多数のほかの、そしてそれに先行する写真――すなわち伝統――との関係のなかに存在している。写真の場合この伝統はあまりにも短く、複雑で混沌としている。また多くの急激な変化や明白な矛盾を含んでいる。したがって、もっとも優れた写真家たち――一般的にいって彼らは誰よりもこの伝統の内容に敏感なのであるが――ですら、この伝統を直観的かつ衝動的に理解しているにすぎない。もっとも才能に恵まれ、また独創的な写真家たちが彼らの仕事で示しているように、写真は意思伝達のみを目的とした、いわばわれわれの時代の混成語ではない。写真はすべての芸術のなかでもっともアンダーグラウンド的であるかもしれないのである。したがって例外的な地域環境が、この写真というメディアの可能性について、特別な展望を生み出すことも、まだ可能なのである。

これまでの記述で筆者は、近年際立って日本的な写真が生まれてきたという、ショッキングだが否定できない事実を説明しようと試みた。山岸章二とちがって、筆者はこの現象の経緯や意味について、専門的な知識はまったくもちあわせていない。したがって以下に述べることは、この現象に敬意を抱いている局外者の、仮説的なコメントとのみ受けとっていただきたい。

ふり返ってみると、過去20年間に日本の写真に起こった激変は、次の三つの要因によるもののように思われる。まず第一は戦前の絵画主義的写真の伝統の明白な崩壊であり、第二はテクニックとしての写真に国民が魅力を感じたことであり、第三は日本人の生活が驚くべきスピードで変化したことである。

形式と主題の双方において、戦前のシリアスな写真（審美的な志向をもってつくられた作品という意味である）

は、伝統的な絵画の視点を模倣した。その主題は典型的に牧歌的であり、叙情的で、十分に通俗的なものでありまた倫理的に受け入れられるものであった。見たところこれらの写真は整然としたシンプルなパターンで構成され、強い平板さを保ち、またディテールを隠すことを好んだ。そしてそれらは、その時代が直面した問題でさえも、自分からは十分に安全な距離を保った、サロン的、瞑想的なあいまいさで包み込まれてしまっていた。これらの写真は西欧の絵画主義的写真家たちの作品の模倣なのであろうが、皮肉なことに、彼らはその知識の大部分を間接的にだが、日本美術から学びとったのである。そして第二次大戦後のシリアスな写真家たちにとっては、こうした伝統が不適当であったことは明白だった。

戦後の日本において写真熱が国民のあいだに広がったことは、まったく別個の問題である。つまりこの写真熱は美術的な理論や態度とはまったく関係がなく、写真を撮るというプロセス自体に対する愛着と、そしてこのプロセスから生まれるほとんどすべてのものに対して魅力を感じるということに関係がありそうだ。現在一部の日本の写真家が、かつてアメリカで映画の新進スターたちに与えられたものと似た、強烈で、偶発的で、またうつろいやすい名声を与えられるということは、国民の写真熱と関係があるのかもしれない。この写真熱は明白な質的な基準をもたないので、きわめて寛容にどんなものでも受け入れる。

過去四半世紀に、すべての国は大幅な変化を遂げた。しかし日本ほど急激に、かつ恐るべきスピードで変化した国はない。この変化の本質について、ここで詳しく述べる必要はないし、また筆者はこの変化の得失を論じる能力もない。ここで指摘しておくべきことは、日本の極端かつ急激な変化が、本書に収められた写真の中心をなしているということだけである。これらの作品が明白にしていることは、写真が時代のいちじるしい変化の意味を明確にするためには理想的なメディアだということである。なぜなら、写真は柔軟であり、直観的、肉筆的であり、迅速かつ安価、また過渡的であり、そしてある意

味では正確——このある意味というのはまだ理解されていないのだが——だからである。

最近の日本の写真の中心的な特質は、直接的な経験の描写へ向けられた関心である。これらの写真の大部分にわれわれが感銘を受けるのは、経験についてのコメント、あるいは経験を、何かより安定して永続性のあるものへと再構築したものとしてではなく、（明らかに）意図的に自らのコメントを欠いた、経験そのもののはっきりした代替物としてである。森山大道ほど視覚芸術においてオートマティックな描写の理想に近づいた作家の名を、ほかにあげることはむずかしい。そして小原健の高度にシステマティックでコンセプチュアルな作品ですら、意識的な批判や審美的な解釈を強化しようとするより、むしろこれを除外しようと意図しているようにみえるのである。

この新しい精神の誕生を示唆するものは、ヒロシマの生き残りの人々を写した、あの土門拳の圧倒的なシリーズ（1957年）に見られる。土門はこのシリーズを自制と明らかに公正な客観性とをもって制作したが、これらの自制と客観性は、彼のライフワークである日本の伝統芸術のクラシックなドキュメンテーションを貫くものと同じものである。しかしながら、最近の日本の写真界の中心的人物は、間違いなく、東松照明である。東松はその作品を通じて、日本のより若い写真家たちが、自らの存在をはかる原標とする観念、作風、方法論を確立した。

東松の初期の作品は、従来のフォトジャーナリズムの枠組のなかで生まれたものであった。これらの作品が記録した時の流れの一刻一刻は、より大きな一貫したストーリーの一部分として、特別な説明的意味を示唆するものとして選択され、示されたものであった。東松自身が成熟するにつれて、彼の写真が示す内容は伝統的な〝報道価値〟としての意義を主張することが少なくなっていった。彼の写真の表面的なテーマはより日常的となり、またしばしば平凡なものとなったが、写真自体は、生活の体験そのものに対する東松の直観的な反応をよりシャープに、さらに豊かに記録するようになった。東松がジャーナリ

14

スティックなイラストレーションという観念を徐々に拒否していった同じ時期に、世界中の才能ある写真家の精神のなかでもまた同様な変化が並行して起こったのである。しかしながら、東松の作品がもつきわめて個性的な性格と意味は、拒否というような否定的なことばでは説明できない。それは伝統的なジャーナリズムを拒否するのではなく、東松の写真家としての存在証明を規定する、より大きく困難な問題を彼が受け入れたということである。そしていまにして思えば、この問題とはたぶん、日本固有の感受性の再発見と、その再表現であった。

東松の作品に存在するニヒリズムのかげりは、森山の作品において大胆に、また効果的に明示された。たしかに東松において直観であったものが、森山においては神秘主義的といえるまでの反啓蒙主義になり、また東松において悲劇感であったものが、森山においては暗いもの、恐ろしいものに対する神秘的な好みとなっている。

森山の作品のもつ力と説得性そのものが、彼よりもさらに若い日本の写真家たちには、彼の作品に反発する反応を起こさせ、バランスとコントロールをふたたび取り戻しうる表現と、知性の抑制力への呼びかけを試みさせることになった、といえるかもしれない。秋山亮二、小原健、田村シゲル、それに十文字美信といった写真家の作品を見ると、機知や客観性や内省が、写真家の自らの役割の規定のなかにふたたび入ってきたように思えるのである。

最近の日本の写真が最終的にどういう効果をもたらすかについては、それぞれの地域的な表現の継続的な発展という点からも、また世界の写真界に与える影響という点からも、いまは予測することができない。しかし、他の国の写真家たちが、日本の写真から彼らにとってもっとも価値のあるものをとり入れ、そしてこれを自らが用いることができるように変える、ということは考えられる。そしてわれわれは、少なくとも芸術の分野においては、日本の写真家たちが、世界はひとつだけではないのだという、明るい可能性を追求し続けてくれることを期待しうるのである。

山岸章二

日本の写真家たちの場合は、写真を密度の高い一枚の印画として完成させることへの関心はあまり強くない。不得手だともいえる。それは、その伝統やコレクションの設備のある美術館をもたなかったことにもよる。また皮肉なことだが、まだそれが達成されていないにもかかわらず、いまではむしろ、そこに陥りたくないという意識も一部にある。つまり保守的な格式や既存の価値に接近することに疑いをもつ新しい世代の出現は、たとえば美術館や印画の質へのこだわりが、写真表現のアクチュアリティーを拘束するという考えを生みだしている。

仕事をまとめるには、テーマに沿ったイメージをいくつも重層、複合させた一冊の本という形をとる場合が多い。だから前後を形成している他の写真と切り離し、またまず印刷のためのものとしてあった写真を、美術館の壁に並べて鑑賞するのは、意図と方法がそぐわないばかりか、作者が創りあげた価値そのものを見失わせる危険がある。

またひと口に日本の写真といっても広範、多様、しかも流動的で、限られたスペースでその全体像を、普遍的にダイジェストとして組み立てることは不可能に近い。もし仮にそんなものが出来たとしても、現代の国際的な文化や芸術の交流の場において、網羅的、解説的な展示がもつ意義はきわめて薄い。

それに写真が国際的にユニバーサルな言語だという手ばなしの楽観は、すでに伝説になってしまった。

この写真展の準備段階の途中で、私を躊躇させる以上のようないくつかの問題があった。なにしろこの企画は海外における、ある規模をもった、日本の写真家たちの

仕事の紹介としては初めてのことなのだから。そしてその遠巡を実行に踏み切らせてくれたのは、ジョン・シャーカフスキーの次の言葉であった。

「この写真展は、まず参加してもらう写真家に対して、われわれはあなたの仕事の意義を、写真とは何か、という命題との関連において、こう考えた、と告げるものにしよう」

　日本の写真の歴史的な系譜や分類をして、安易な理解に導くのでなく、古くて新しいその命題に一歩近づくための、素材的な役割を果たすという合意点に立って、「ニュー・ジャパニーズ・フォトグラフィー」の作品は選出された。展示は参加した15人の写真家それぞれによって創りだされた、個々の独自な価値基準そのものを、連鎖個展という形式で示すことに主眼をおいて構成した。

　新しい写真の概念が、対象をいかに写真家の主体性によって表現するか、という美意識の問題を離れて、写真家と対象との直接的な関わり合い、さらには写真家自身の存在証明の表出として認識されつつあることはいうまでもない。これらの写真が結果としてシャーカフスキーのいう「日本的な写真の出現」を示す例証になったとしても、私としては欧米と日本という対立した関係で、日本の写真の様式の特異性を提出したつもりはない。あくまでも同時代的な関心と自由な発想のうえに立った、一群の優れた写真家たちの仕事に即して、現代の写真がもつ共通の意義をさぐりだす、ふだんの作業の一環だった。

　この写真展の内容は、中核をしめている東松照明の作品によって象徴されている。それは若き日の東松をして「占領——とつぜん与えられた奇妙な現実」と呼ばせた、連合軍の占領にはじまった第二次大戦以後約30年間の日本の歩みであり、東松という多感なひとりの人間の関心の軌跡でもある。これらの写真はすでに彼の6冊の写真集に収録されているが、それらが単にその間の日本の状況をカメラの対象物として記録したものでないことは、明らかである。ひとつの時代における経験の具体的な内容は、その経験を共有して生きた人々にしか記憶されないが、優れた表現者によって抽象化された新たな価値体系は、そうした限定を越えて、自由な伝達の可能性を開いているはずである。

　日本の伝統美への再認識(土門拳、石元泰博)、大戦に青春を捧げた若者たちへの鎮魂歌(川田喜久治)、欧米文化史への属目(IKKO)、新たな性への挑戦(細江英公)をここでは前半部にとりあげている。それらに続く世代はコンテンポラリーな日常性追求への模索を試みるいっぽう、家族制度や生活環境の荒廃という現実のなかで、日本固有の信仰、土俗性、エロチシズムというような、原点回帰的な主題のもとに、よりデモーニッシュな世界に目を向けている(深瀬昌久、内藤正敏、一村哲也、土田ヒロミ)。また森山大道の精力的な創作活動は、感傷的な自家撞着と荒々しい自己破壊の葛藤に、あえて立ち向かおうとしているようだ。展示が明るい画面に転換する秋山亮二の仕事には●新しい世代の楽天性を、そしてそれに続く若者たちの仕事(小原健、田村シゲル、十文字美信)は、すでに写真が個性や自我の表現であるまえに、それぞれの日常性のなかで、誰もが共有できる意識の形でもあることを明瞭に示している。

　この時期にわれわれは現代写真の核になる部分について、その多くをアメリカから帰った石元泰博に学んだ。いまにして思えば、その思想や技術は余人の手からでも習得できたかもしれないが、現代の写真が目ざす理想には、石元なしでは近づけなかったであろうことをここに明記したい。

　ともあれ、西欧にその源泉をもつ他の表現ジャンルと事情を異にして、発明から時を経ずして、この国に渡来した写真術の種子が、その固有の文化的土壌に根をおろし、いま130年を経過してここに異花受粉的結実をみせている。その果実の中から普遍性という種子をさがしだしてみようというのが、私たち二人の関心であったのだ。

New Japanese Photography

Ken Domon

All pictures made 1940–54, from
The Muro-ji (1954)

The Muro River with the Figure of
Miroku Carved in the Cliff (Spring)

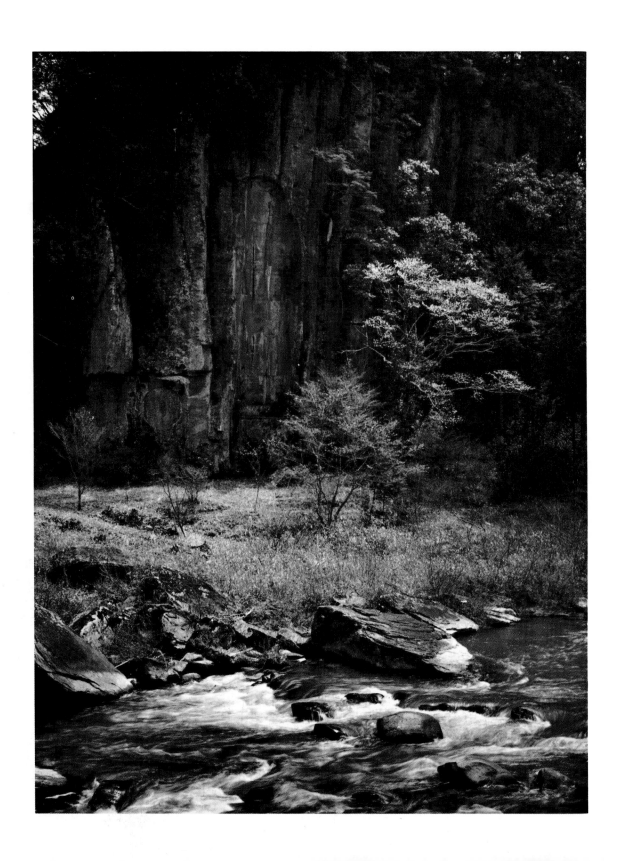

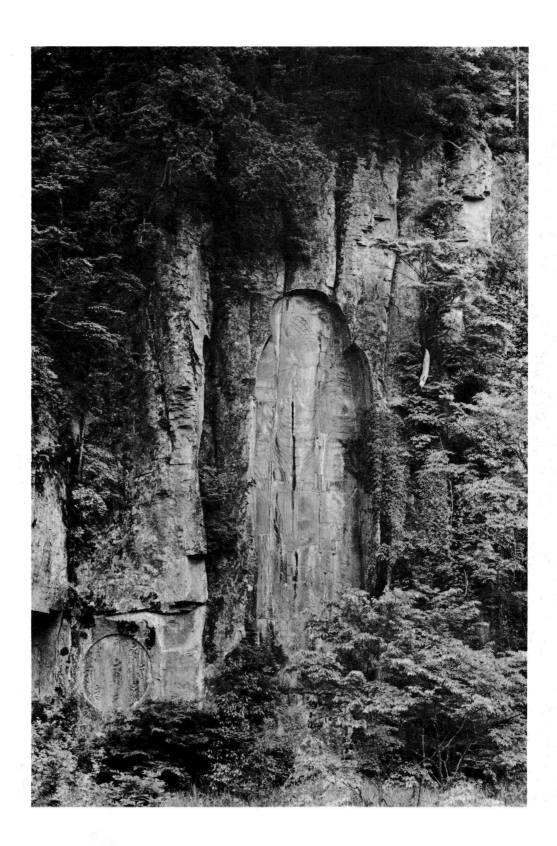

Ken Domon The Muro River (Summer)

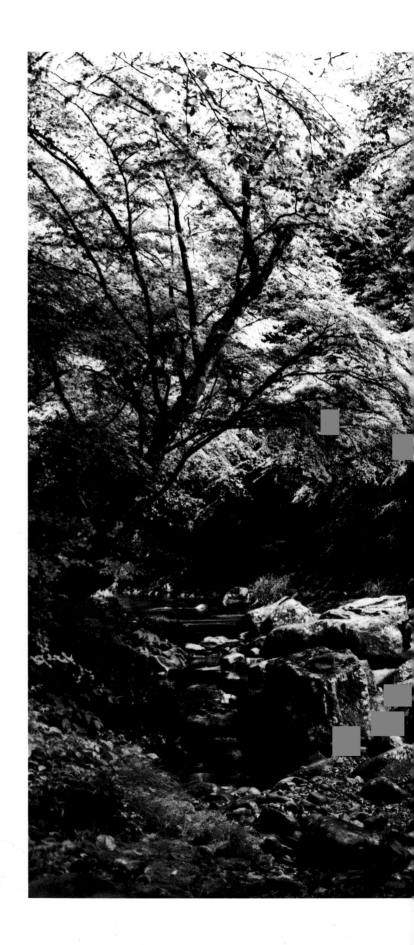

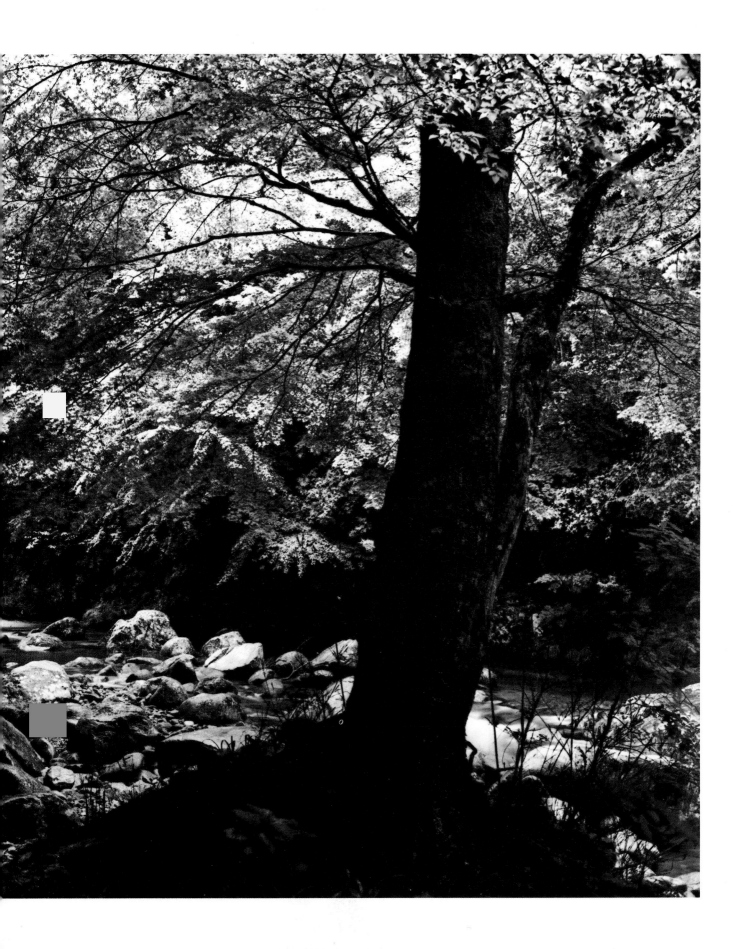

Ken Domon

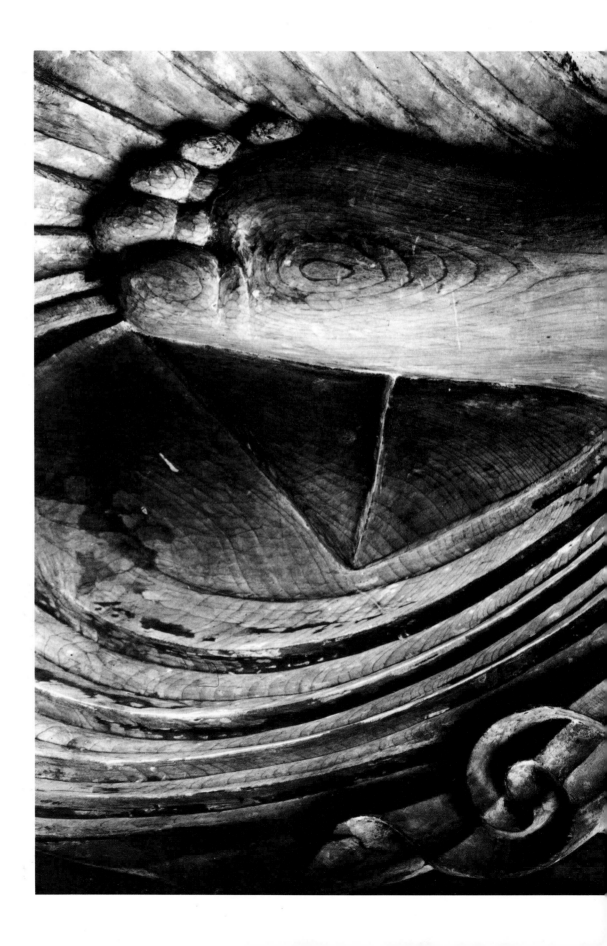

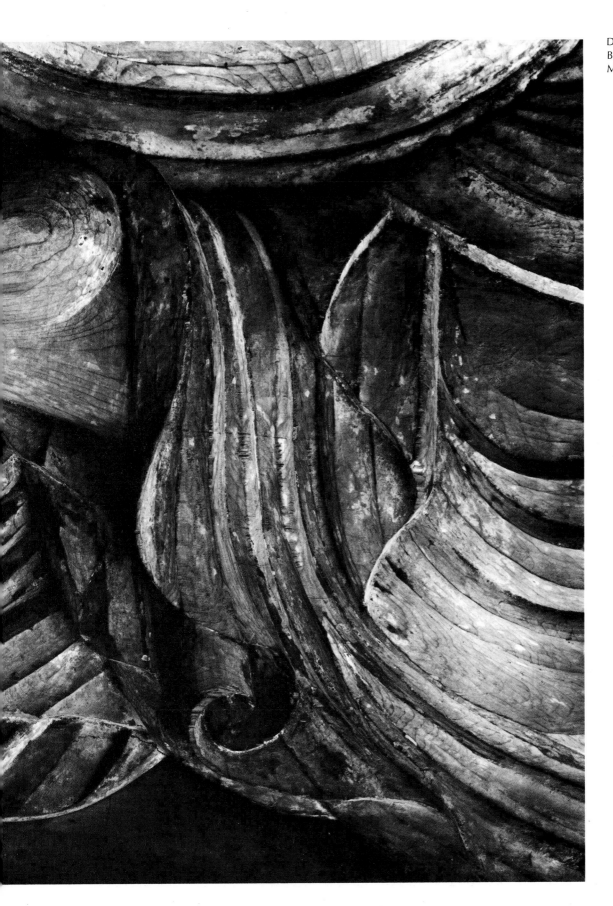

Detail of the Sitting Image of
Buddha Shakamuni in the Hall of
Miroku, the Muro-ji

Ken Domon Rear View of the Image of Miroku

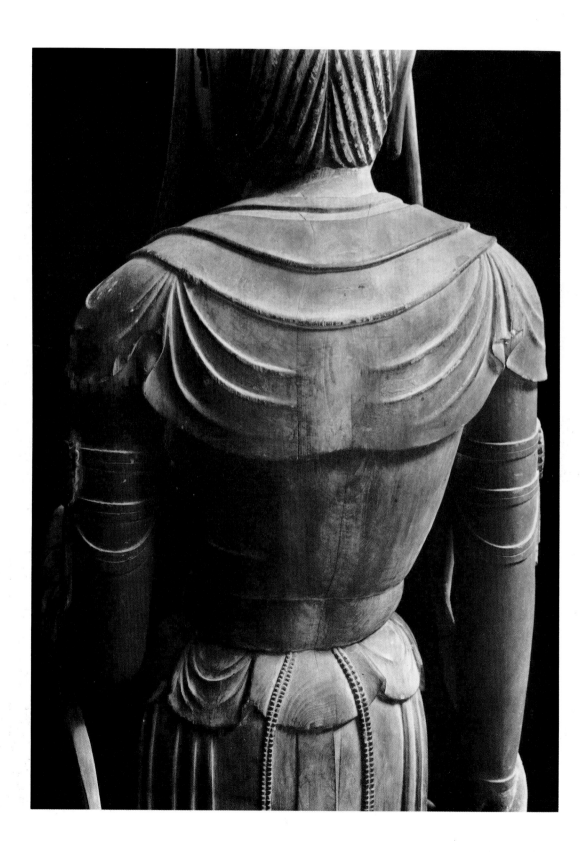

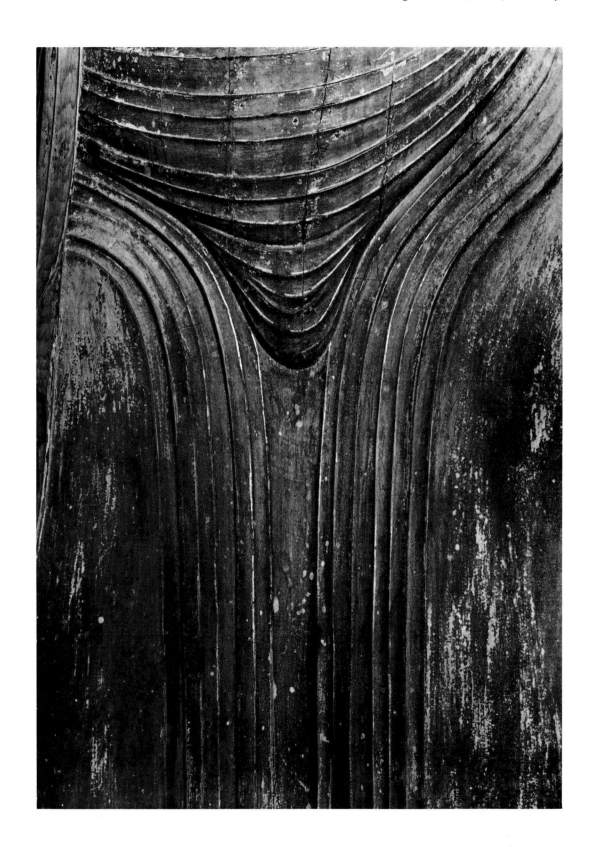

Detail of the Standing Image of
Buddha Shakamuni, the Central
Figure of the Main Hall, the Muro-ji

Ken Domon Detail (right hand) of the Sitting
Image of Buddha Shakamuni in the
Hall of Miroku, the Muro-ji

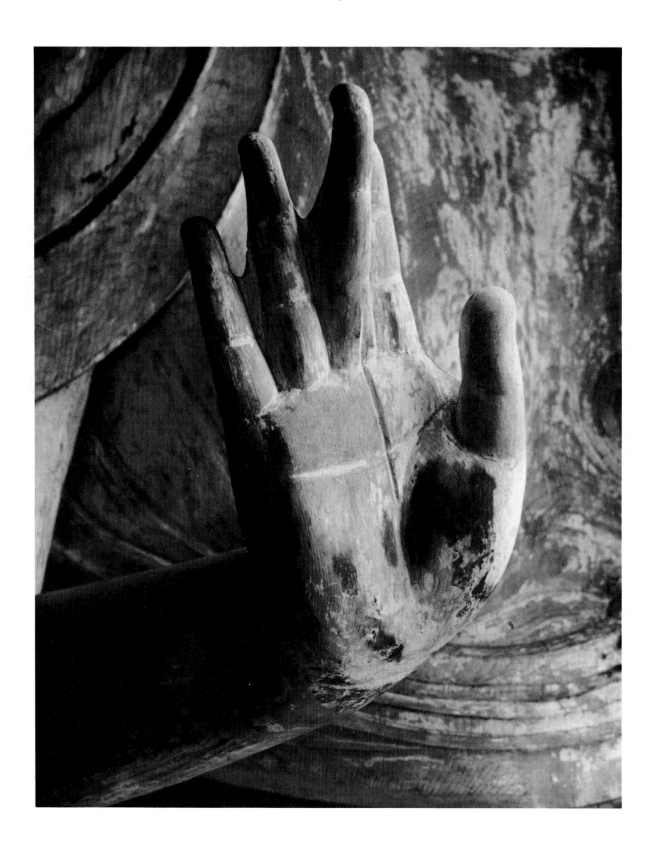

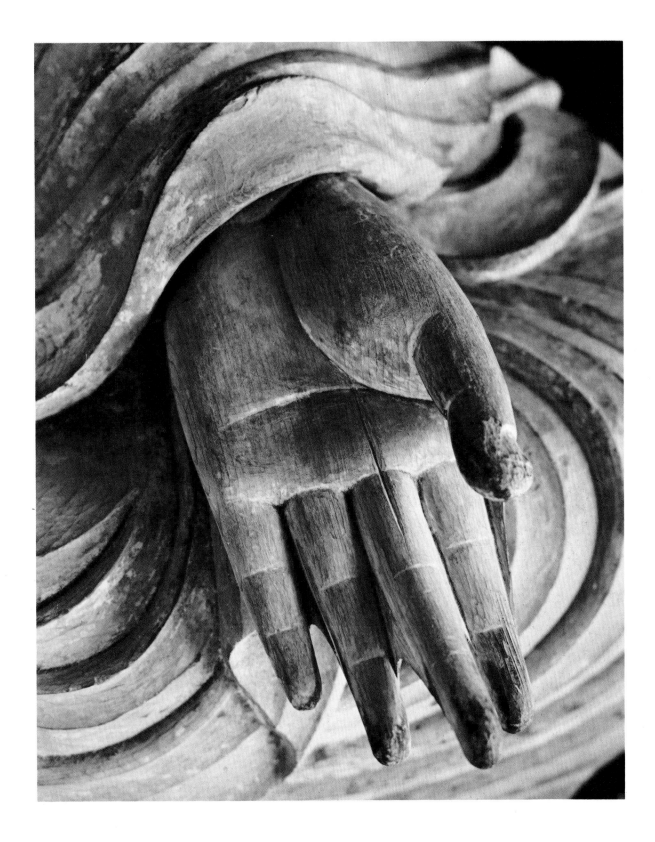

Detail (left hand) of the Sitting
Image of Buddha Shakamuni in the
Hall of Miroku, the Muro-ji

Yasuhiro Ishimoto All pictures made 1953–54, from Stepping-Stones of the Katsura
Katsura (1960) Palace, Kyoto

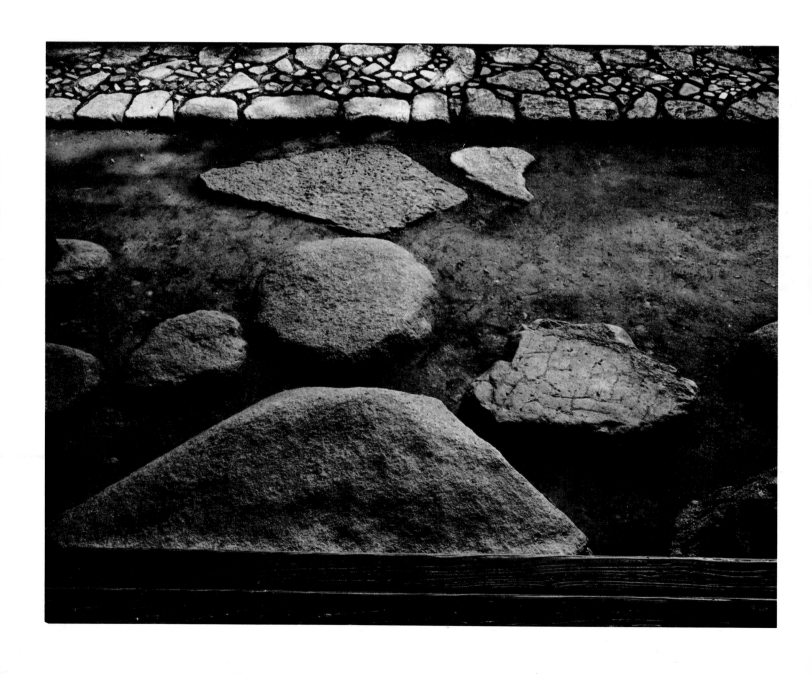

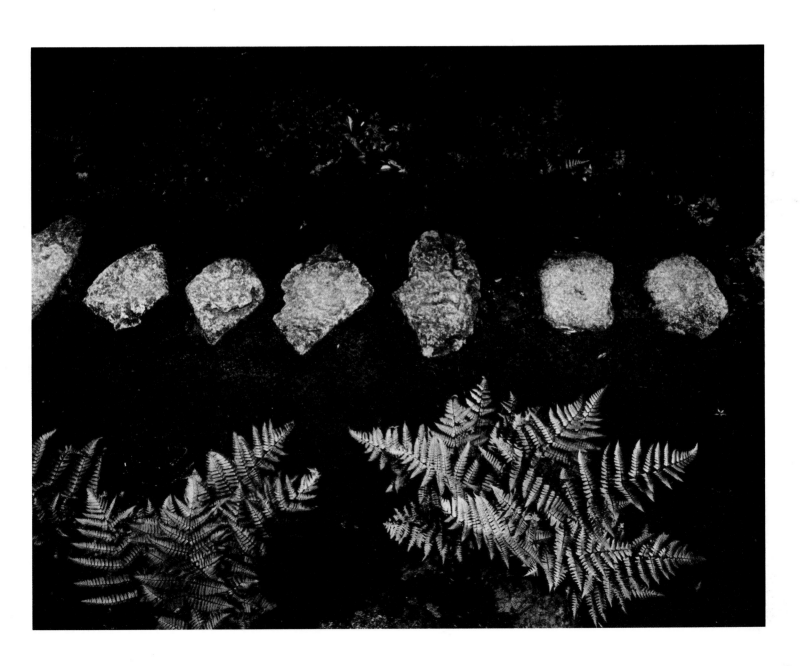

Yasuhiro Ishimoto

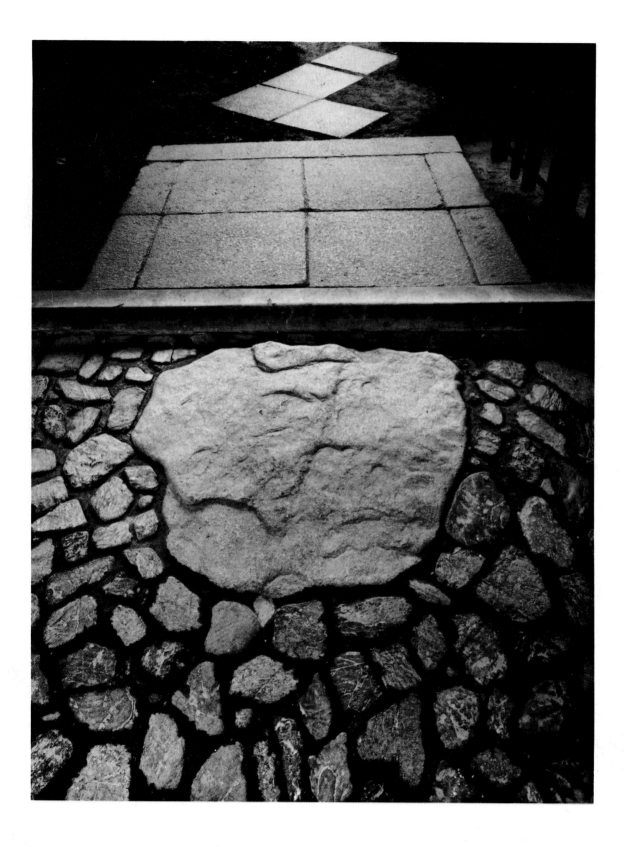

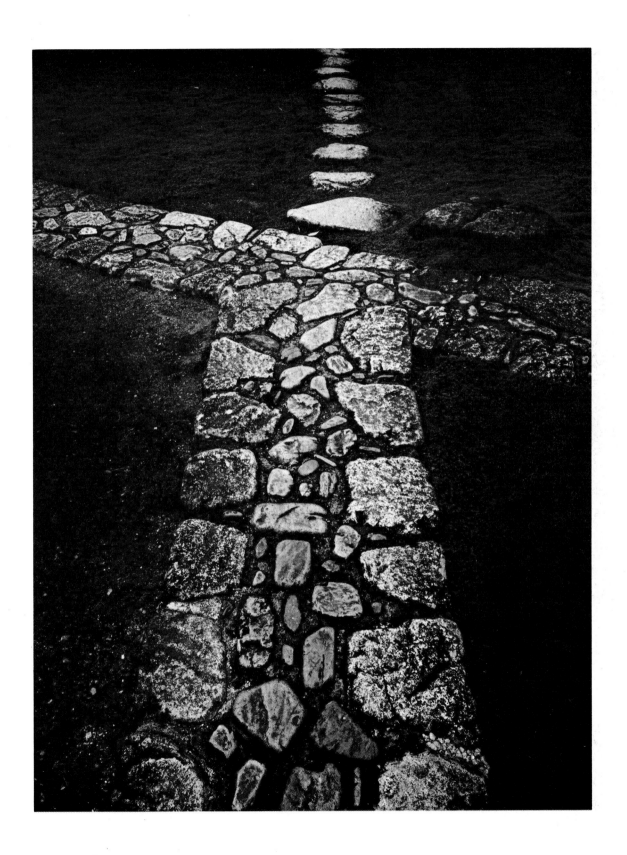

Shomei Tomatsu Beer Bottle after the Atomic-Bomb
Explosion. 1960–66. From *11:02—
Nagasaki* (1966)

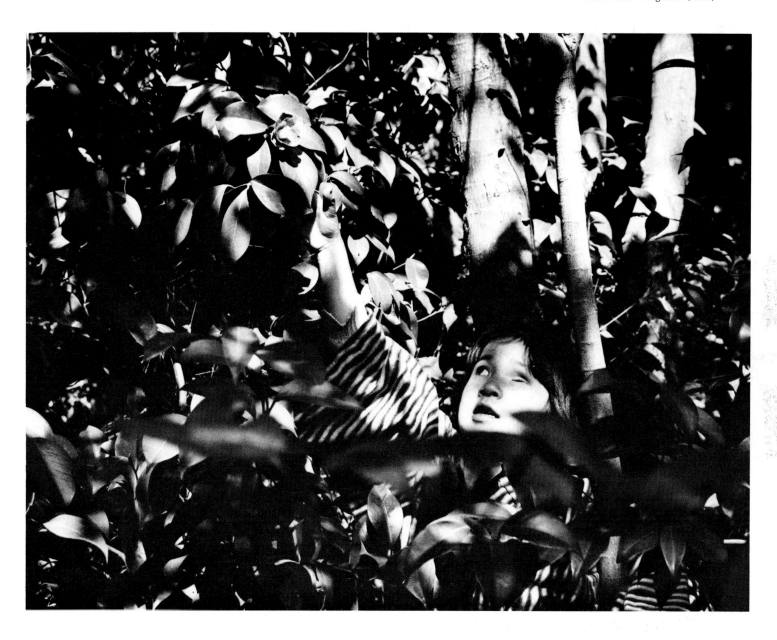

Shomei Tomatsu Aftermath of a Typhoon, Nagoya.
1959. From *Nippon* (1967)

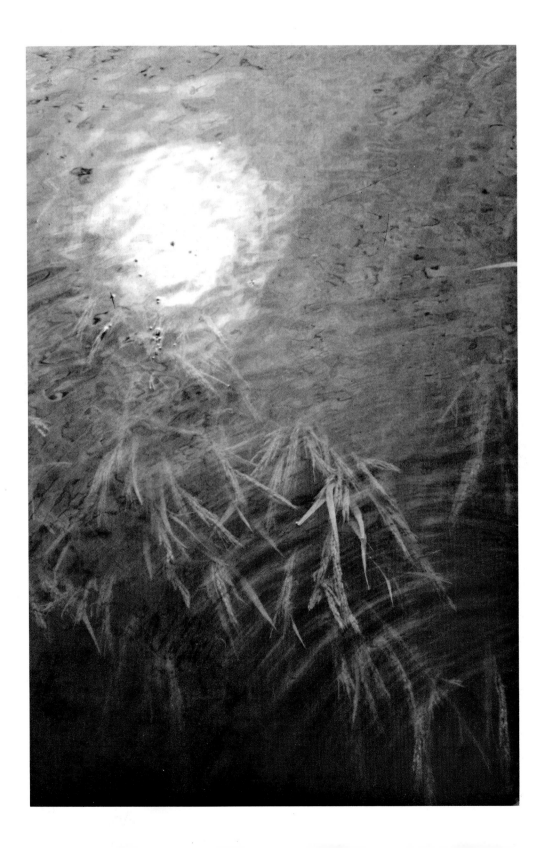

34

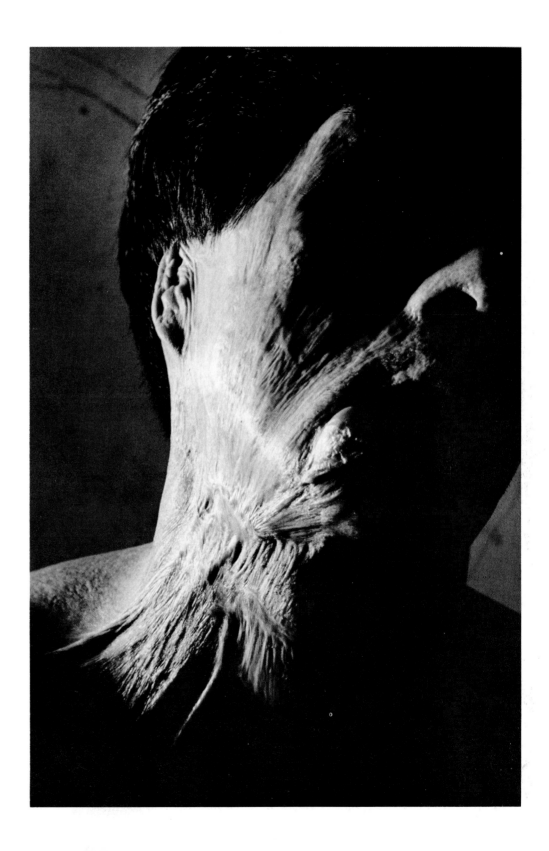

Shomei Tomatsu Aftermath of a Typhoon, Nagoya.
 1959. From *Nippon* (1967)

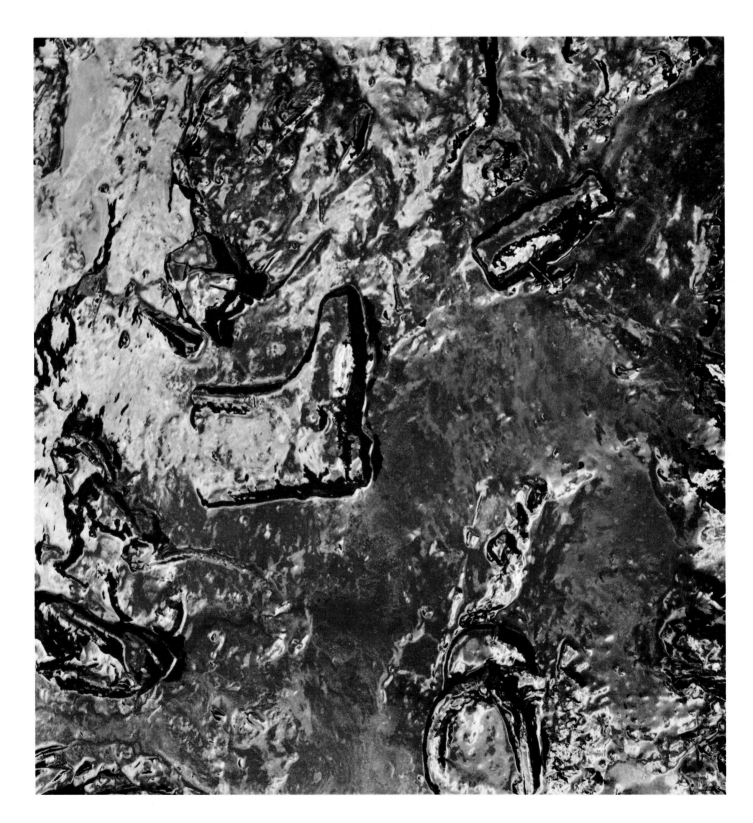

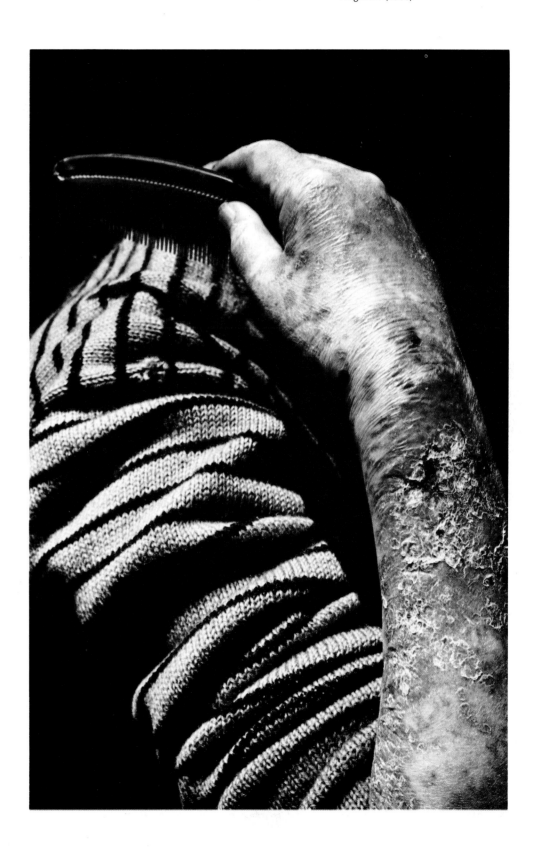

Woman Suffering from an Atomic
Disease. 1960–66. From *11:02—
Nagasaki* (1966)

37

Shomei Tomatsu

The River Styx, Aomori. 1959. From
Nippon (1967)

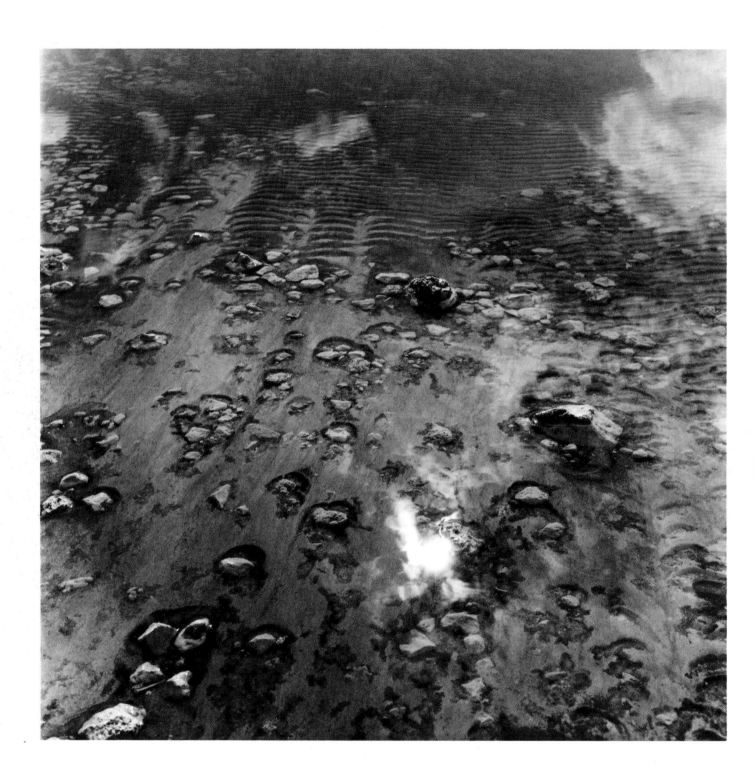

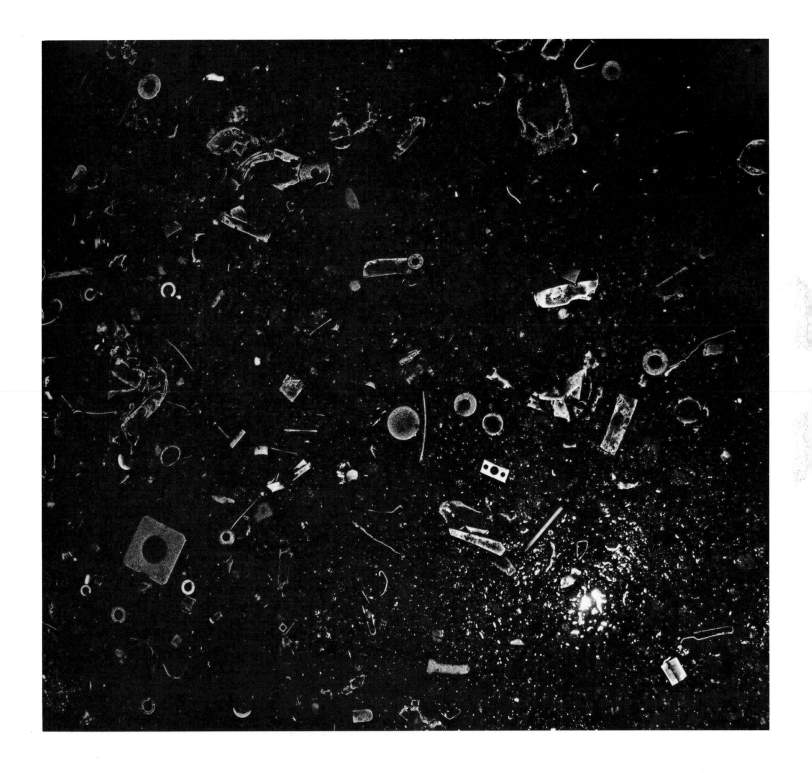

Shomei Tomatsu Aftermath of a Typhoon, Nagoya.
 1959. From *Nippon* (1967)

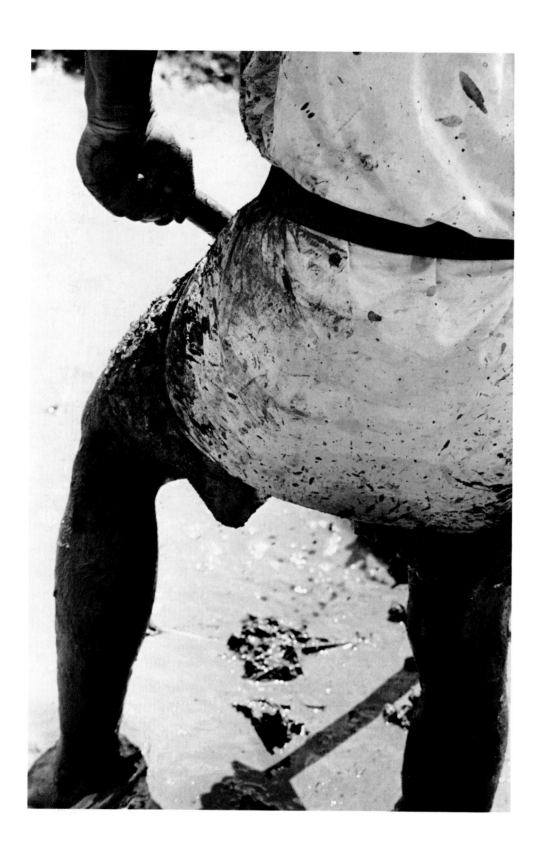

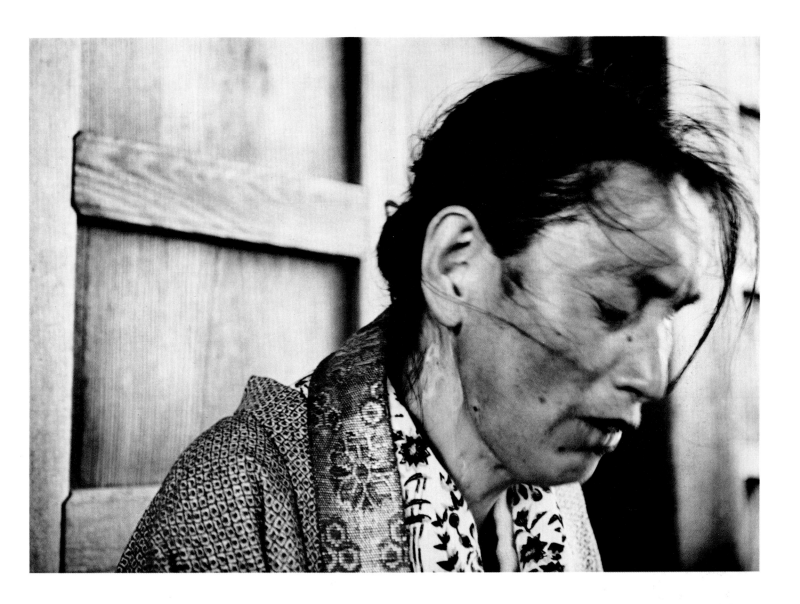

Shomei Tomatsu

Home of an Old Family—Kitchen
Sink, Kyushu. 1960. From *Nippon*
(1967)

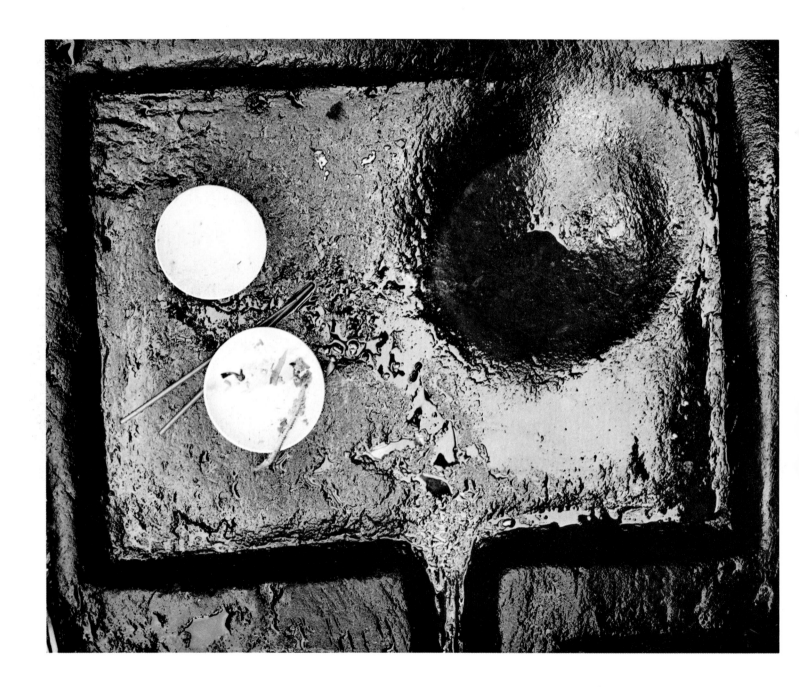

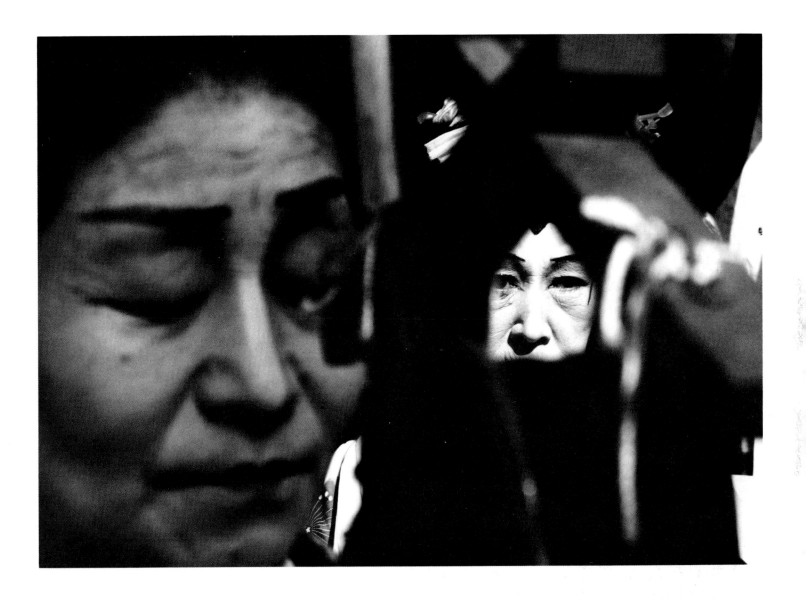

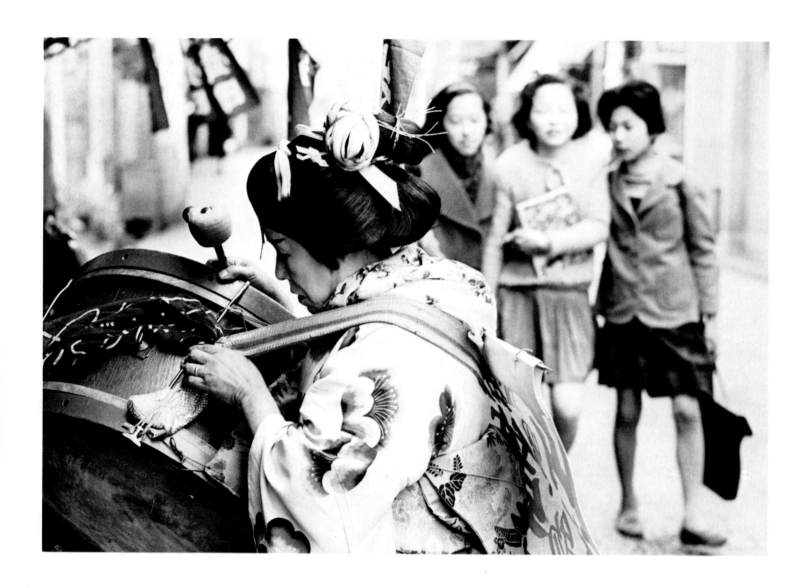

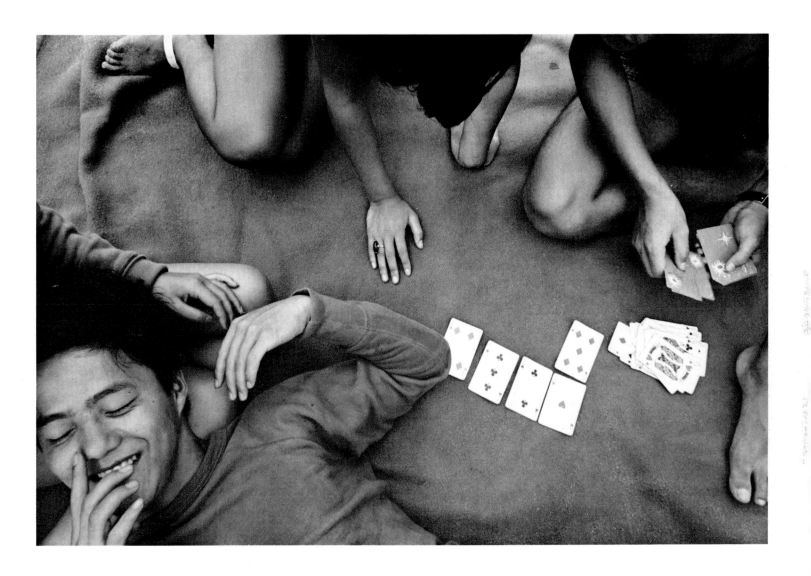

Shomei Tomatsu Protest, Tokyo. 1969. From *Oh Shinjuku!* (1969)

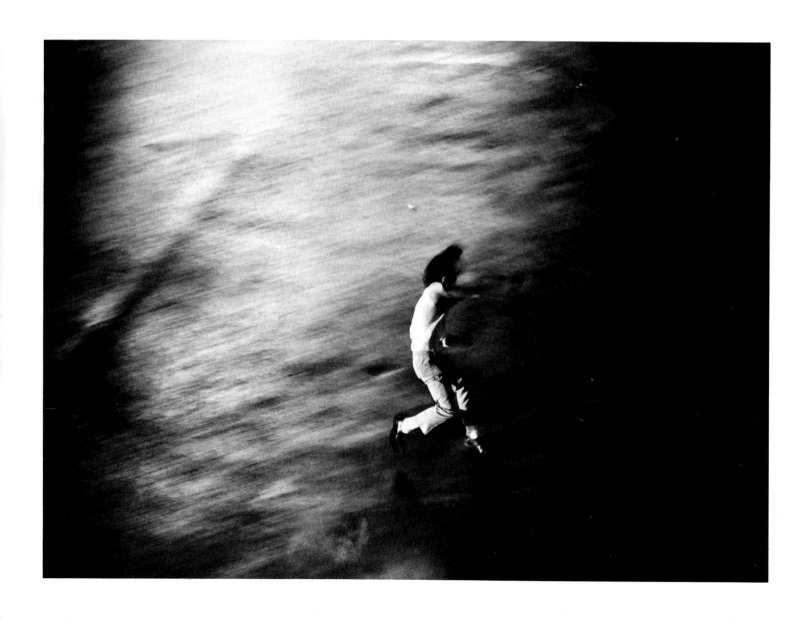

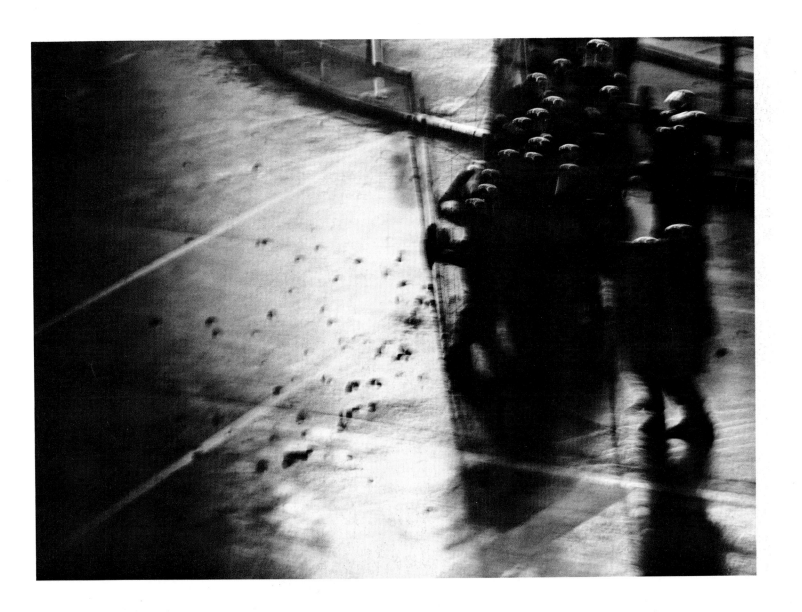

Shomei Tomatsu Tea Ceremony at the Official
Residence of the Head of the
Okinawa Government. 1969. From
Okinawa (1969)

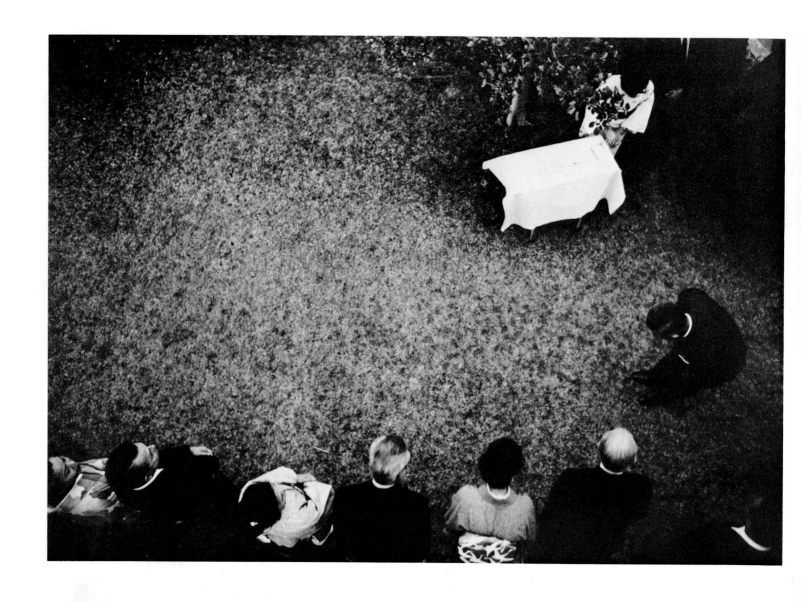

At the Harbor View, a U.S. Army
Officers' Club. 1969. From *Okinawa*
(1969)

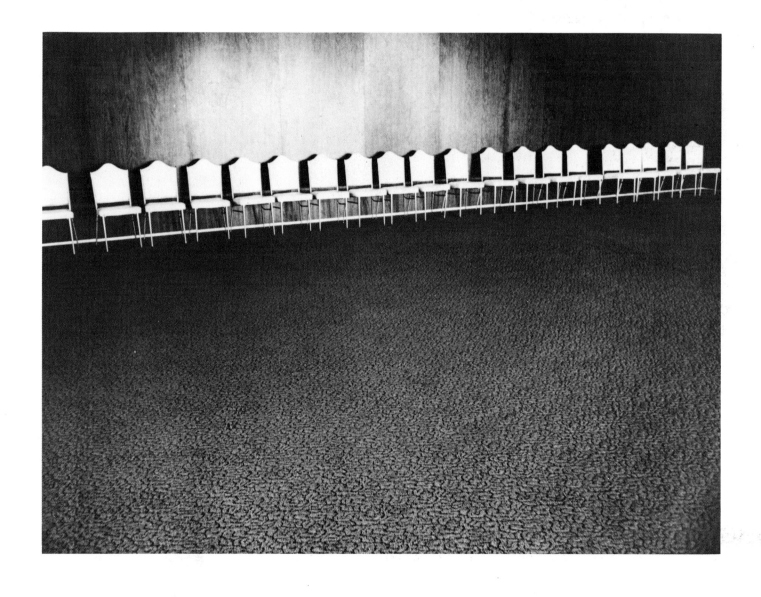

Shomei Tomatsu B-52 Taking Off from Kadena Air
Base. 1969. From *Okinawa* (1969)

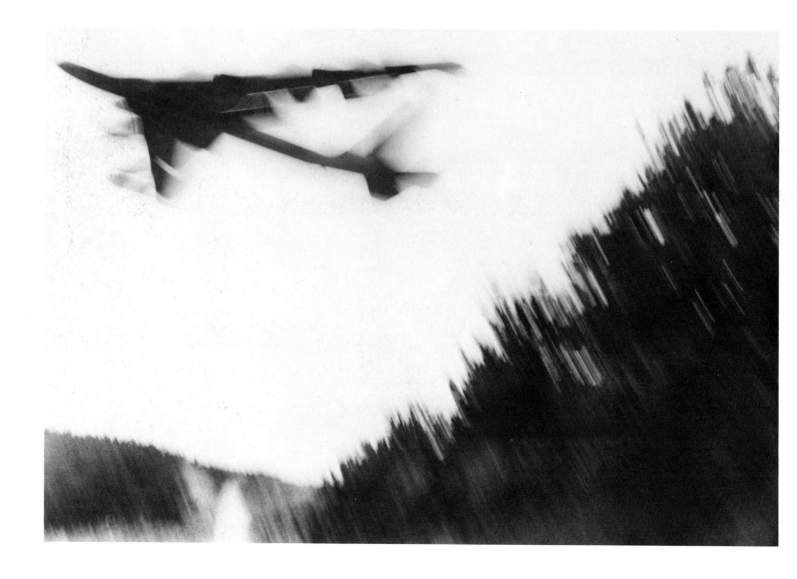

Okinawan Victim of the Atomic-
Bomb Explosion in Hiroshima. 1969.
From *Okinawa* (1969)

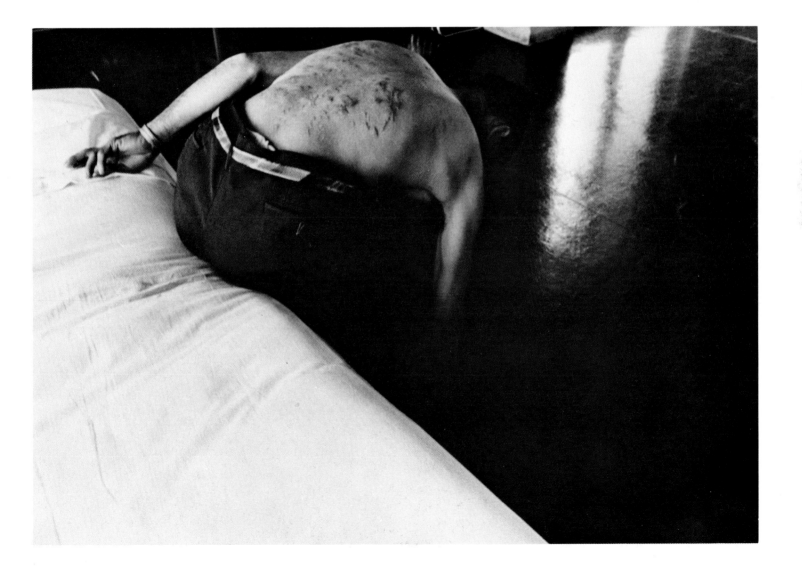

Okinawan Victim of the Atomic-
Bomb Explosion in Hiroshima. 1969.
From *Okinawa* (1969)

Kikuji Kawada All pictures made 1960–65, Scraps
from *The Map* (1965)

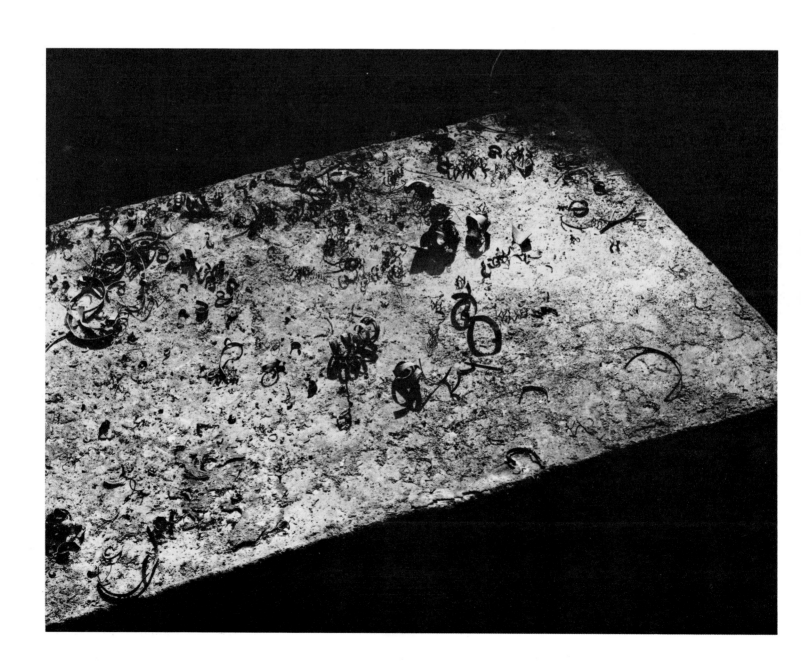

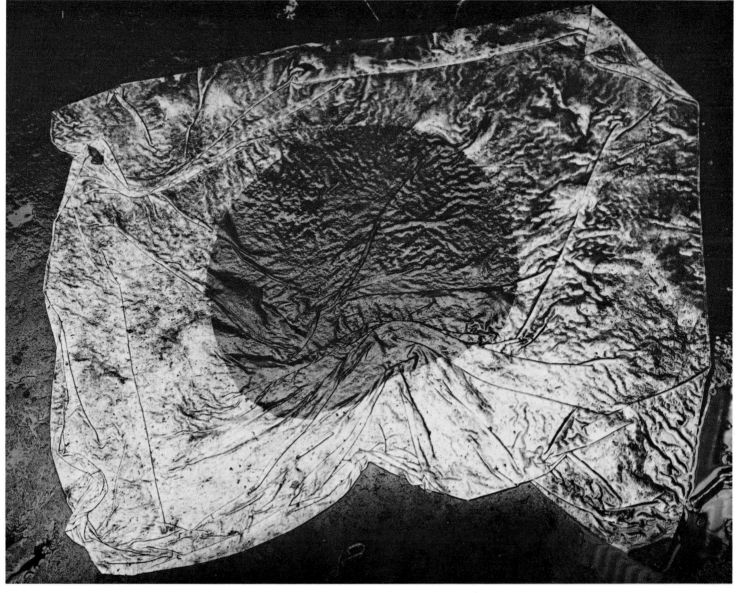

Kikuji Kawada

Photograph and Personal Effects
of a Kamikaze Commando

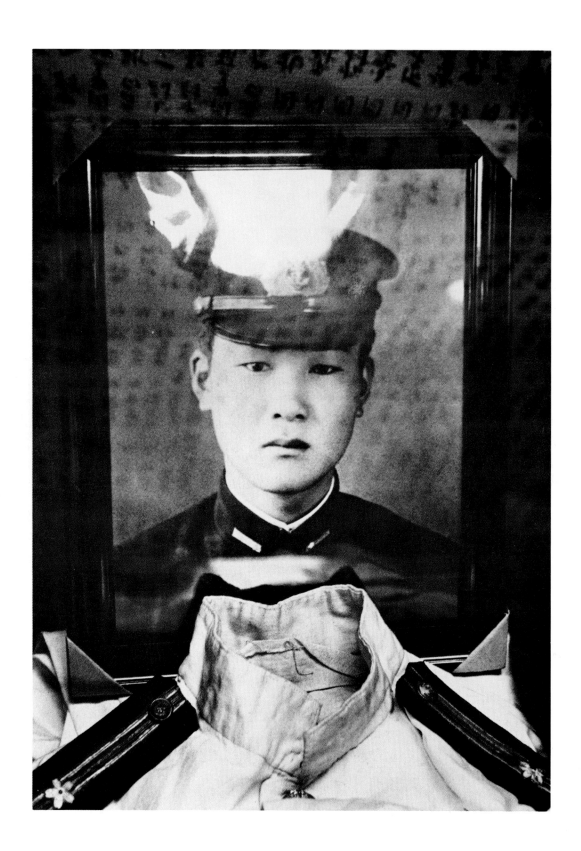

Ceiling, Atomic-Bomb Memorial
Dome

Masatoshi Naitoh Hags. 1968–70

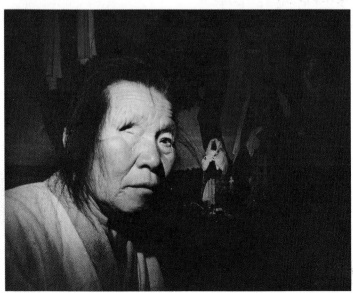

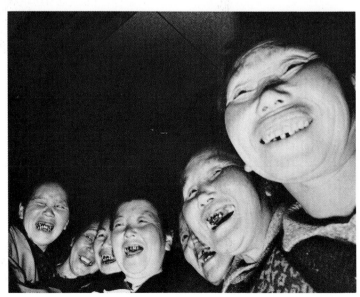

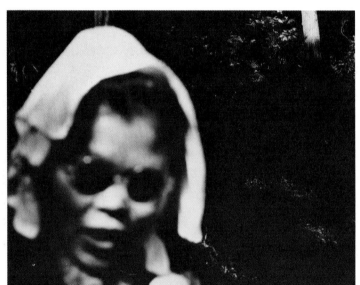

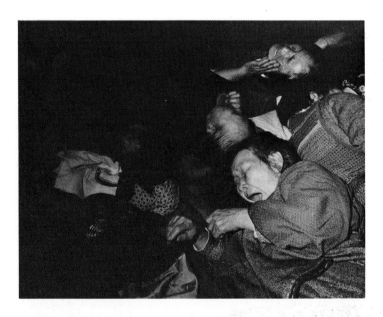

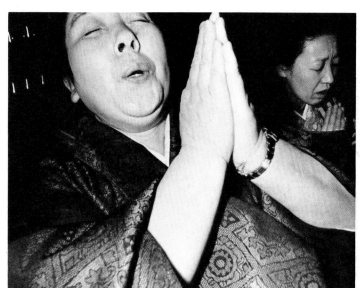

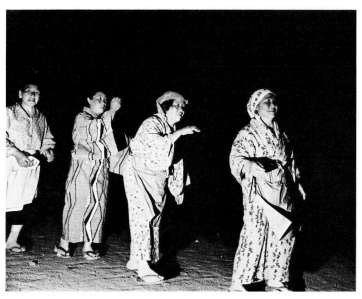

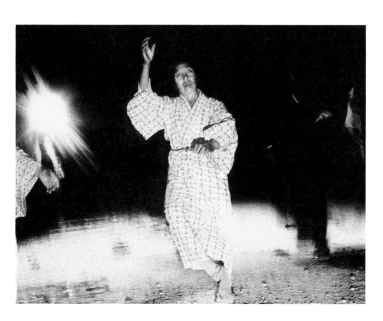

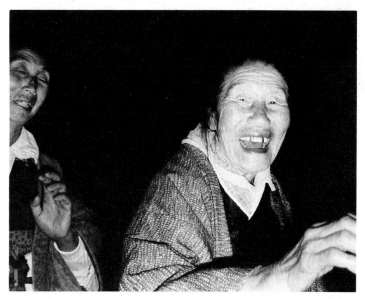

Tetsuya Ichimura Nijubashi, Imperial Palace, Tokyo.
1965

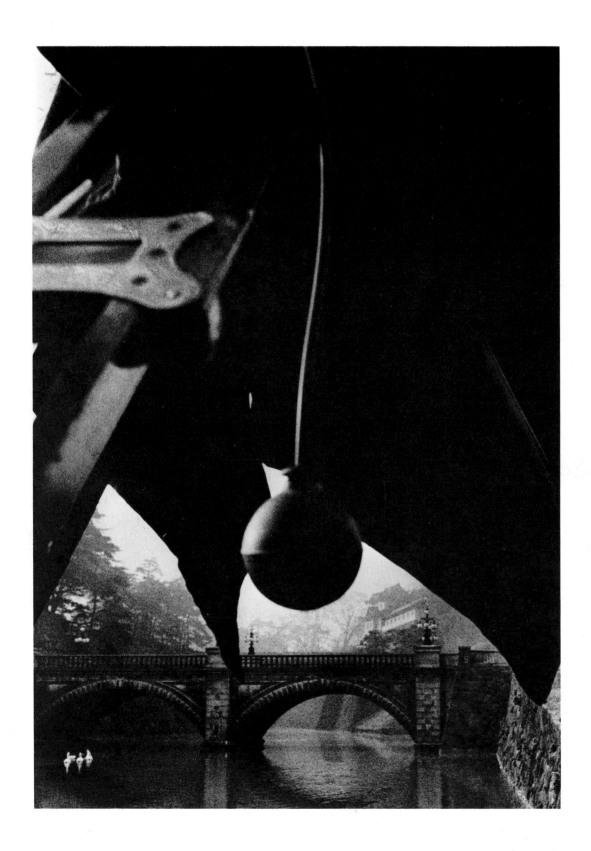

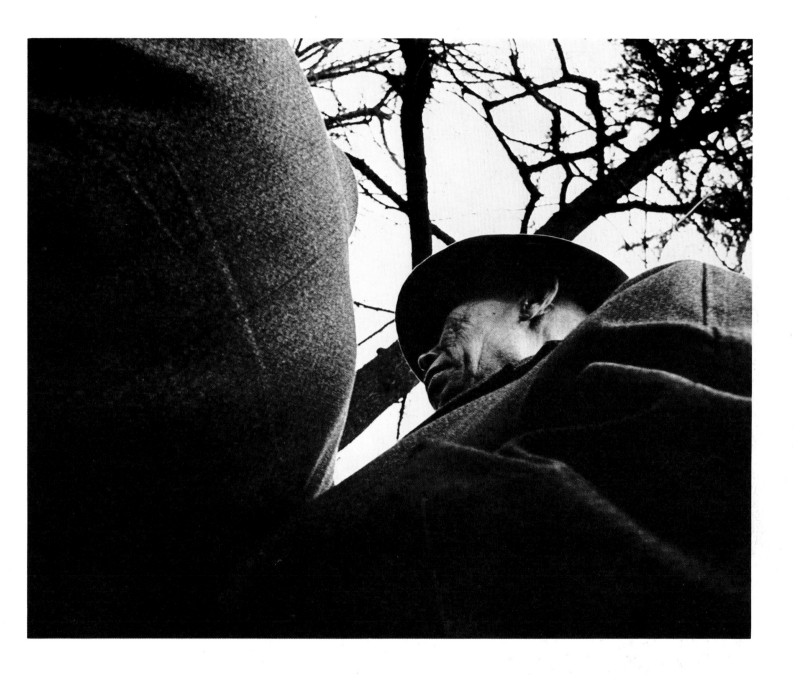

Tetsuya Ichimura Kimono, Shinjuku, Tokyo. 1964

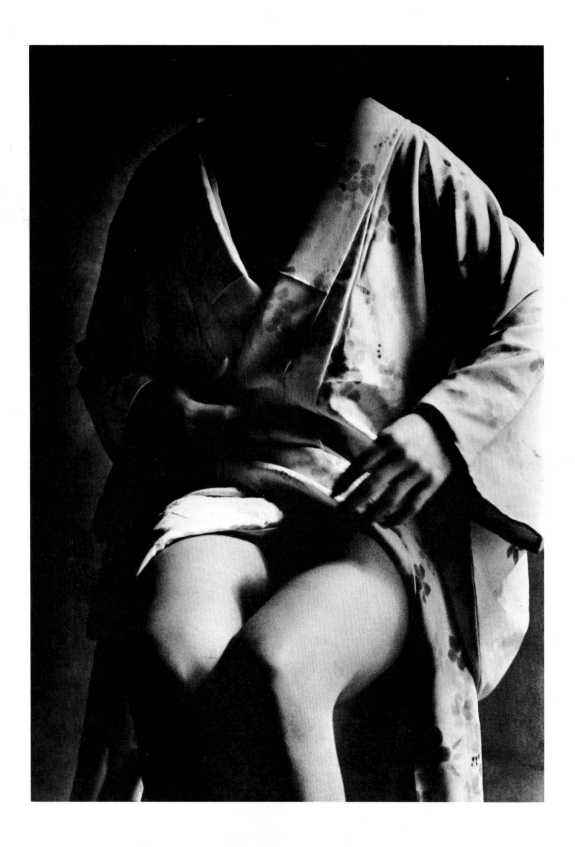

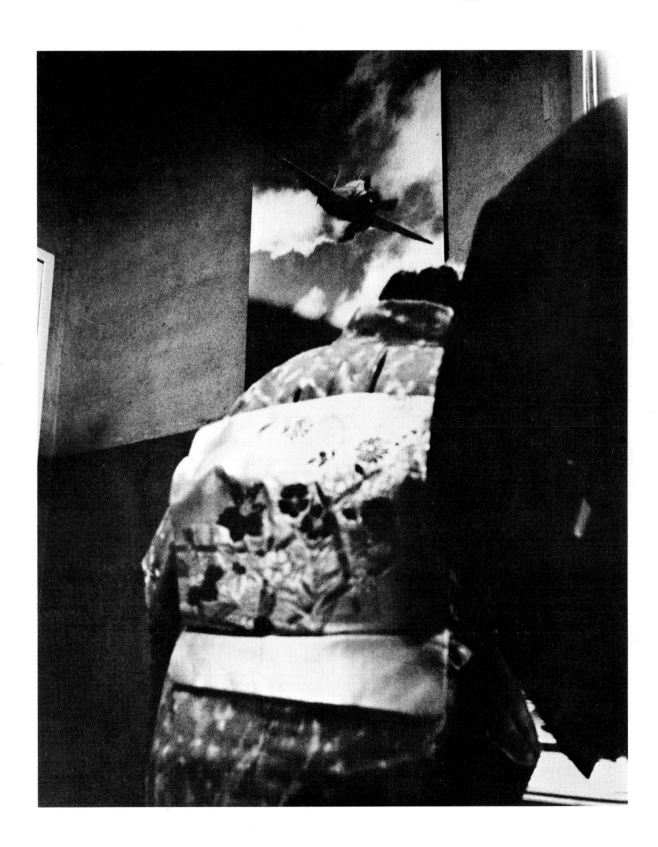

Tetsuya Ichimura Meiji-maru, Etchu-jima, Tokyo.
1967

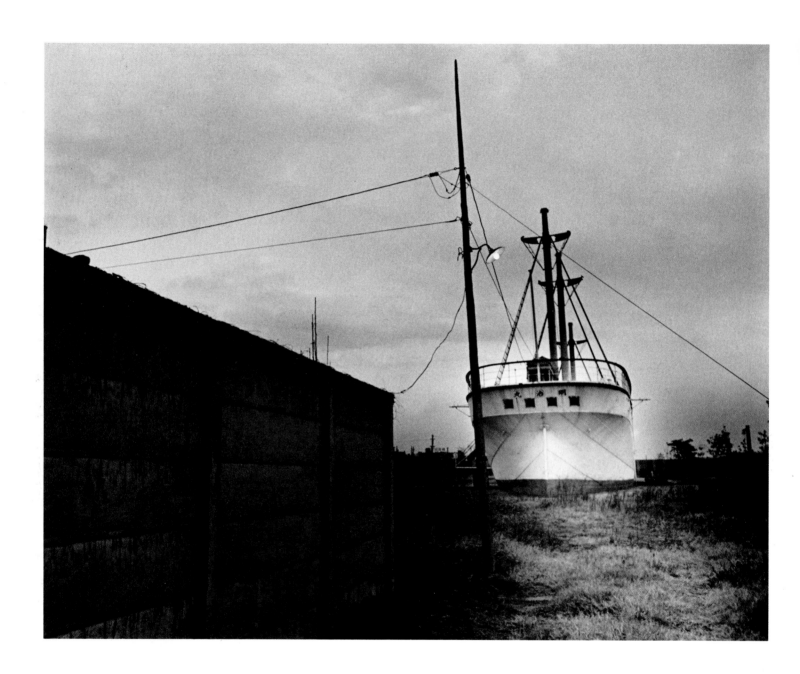

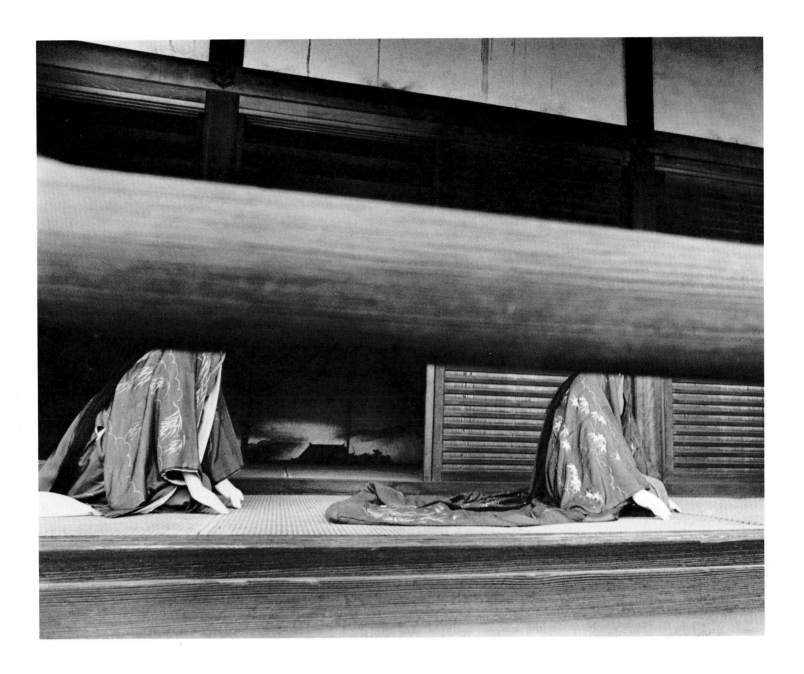

Hiromi Tsuchida

Untitled. 1972. From the series
"Japanese Bondage"

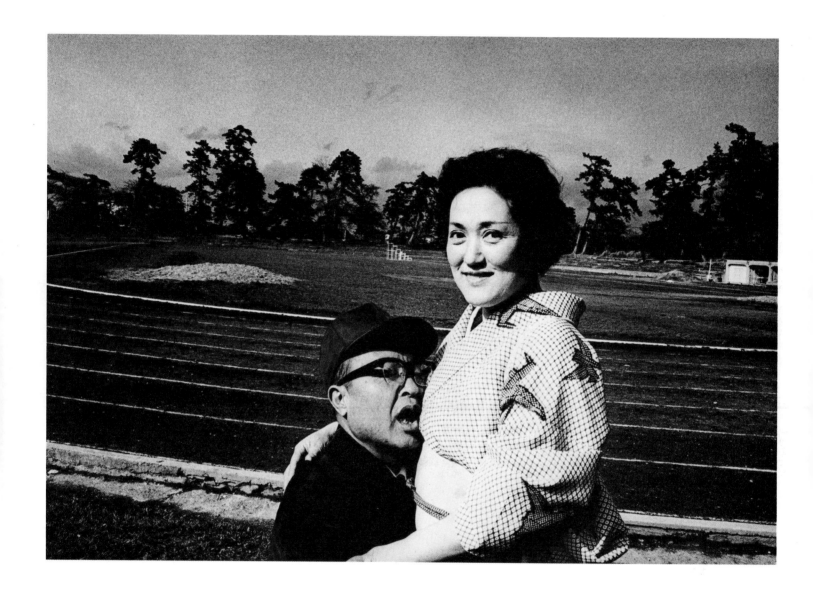

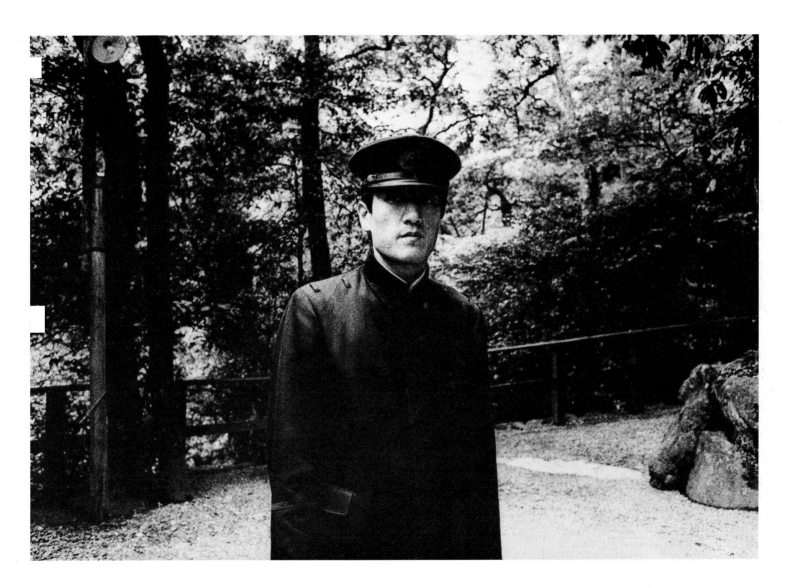

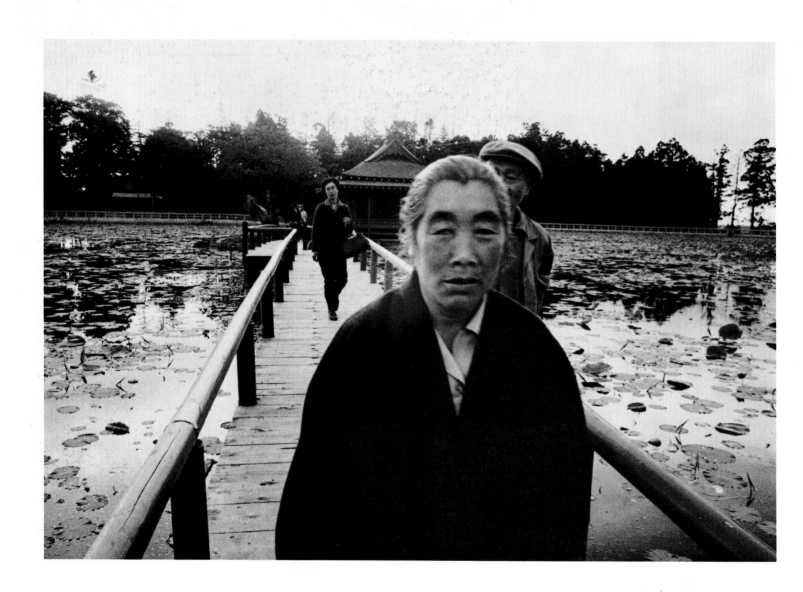

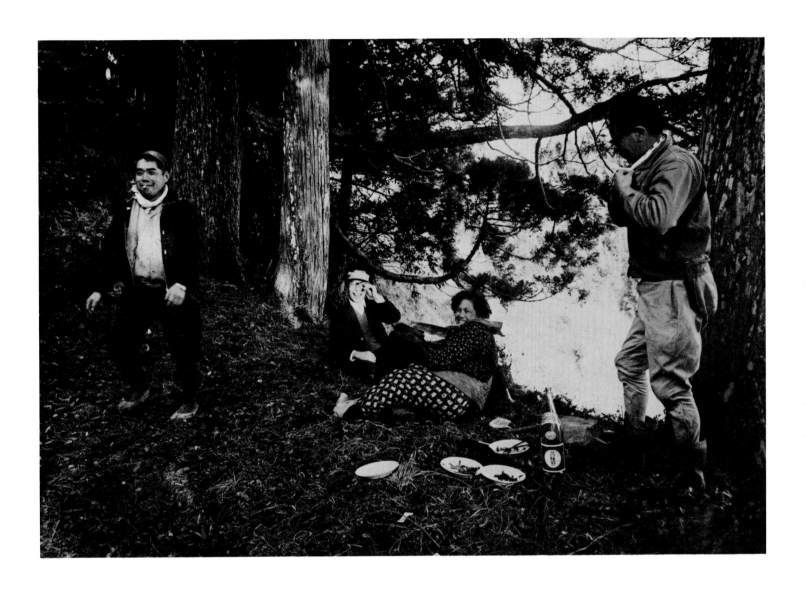

Masahisa Fukase All pictures from the series Yohko. 1963
 "Yohko" (1961–70)

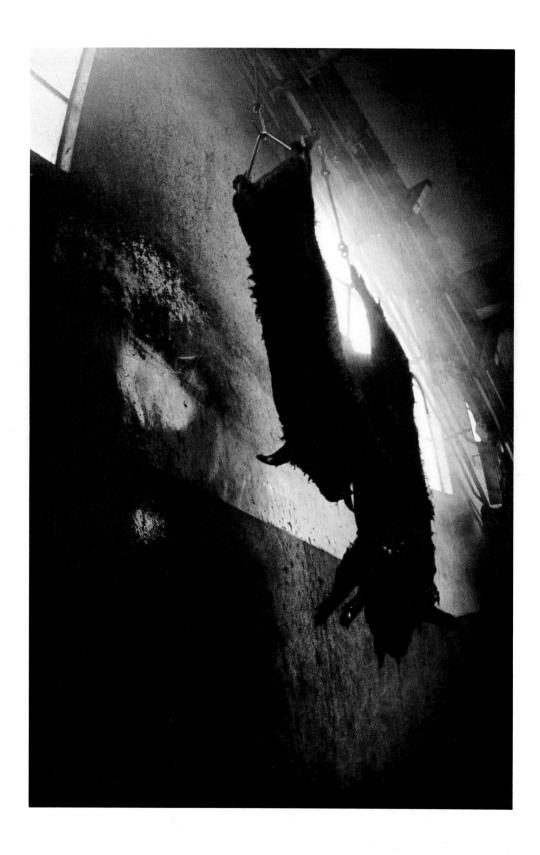

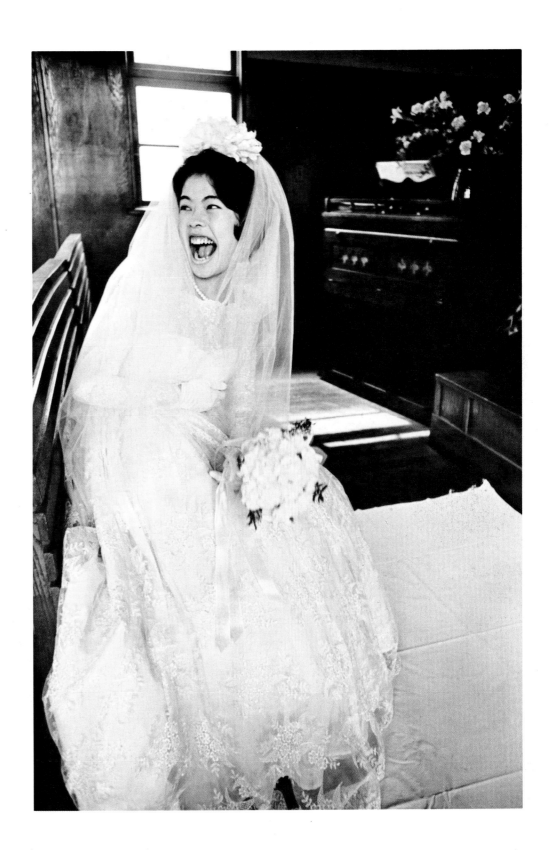

Masahisa Fukase Yohko. 1963

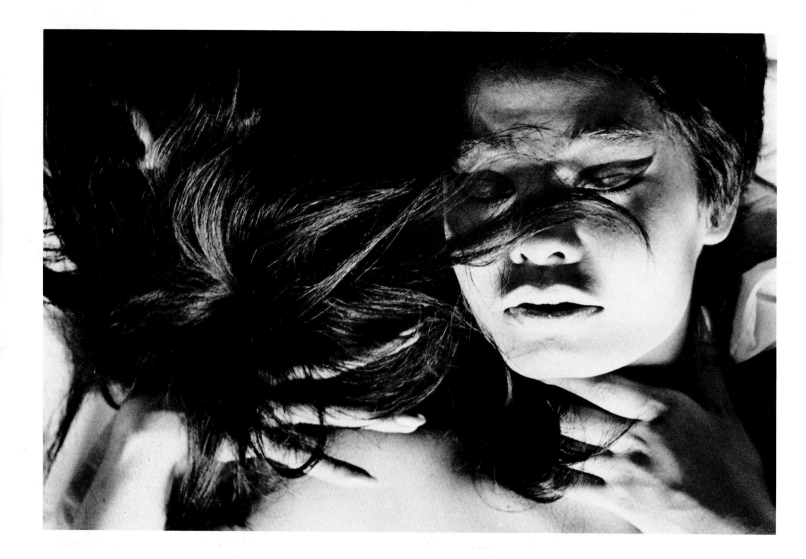

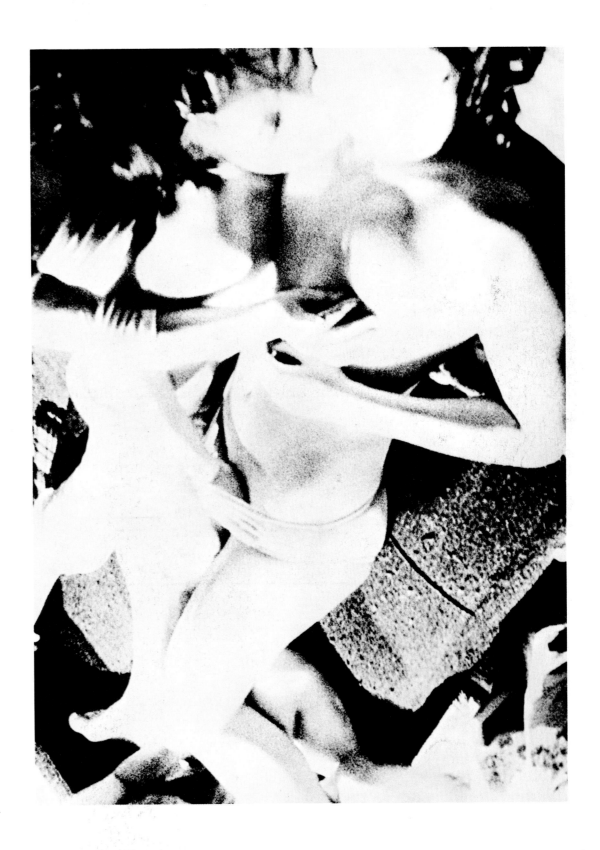

Masahisa Fukase Yohko. 1963

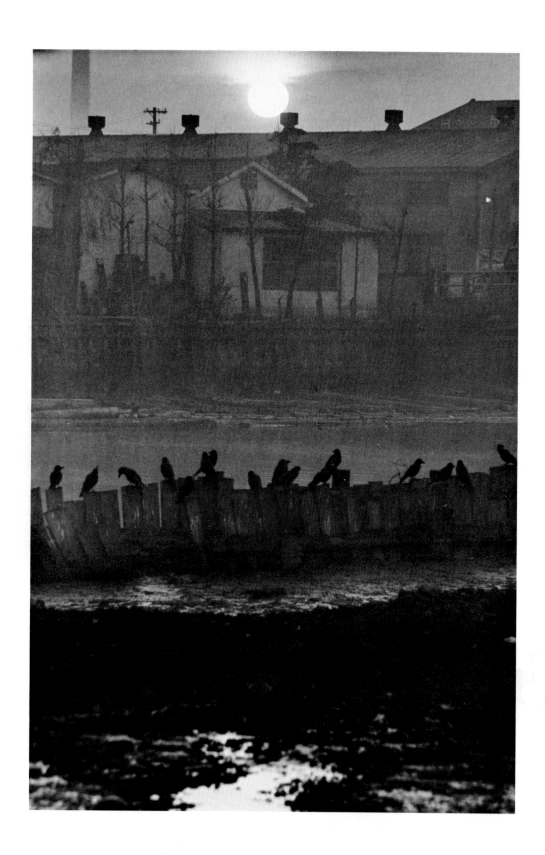

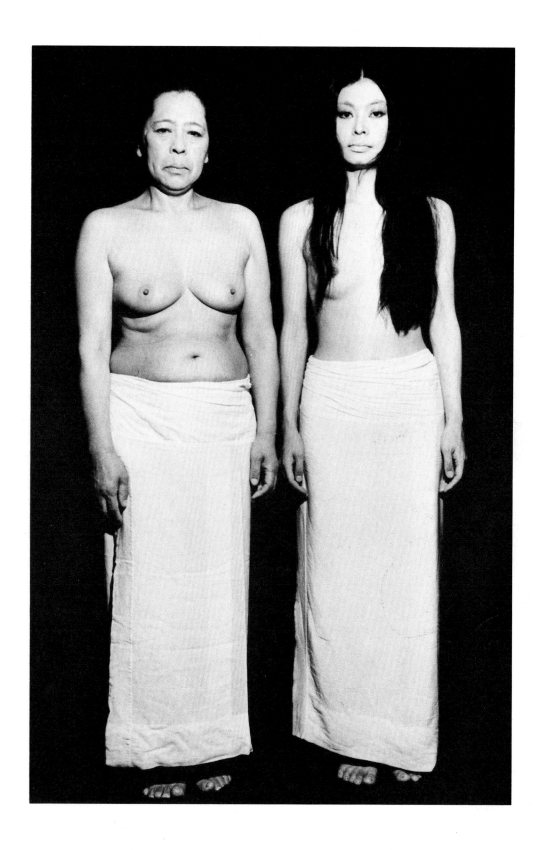

Ikko

Room No. 9, Women's Prison,
Wakayama. 1958. From *Man and
His Land* (1971)

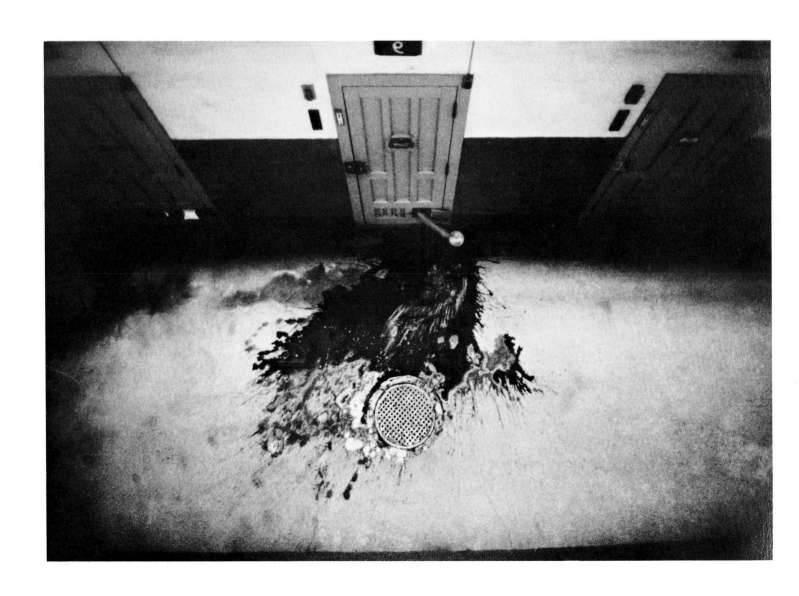

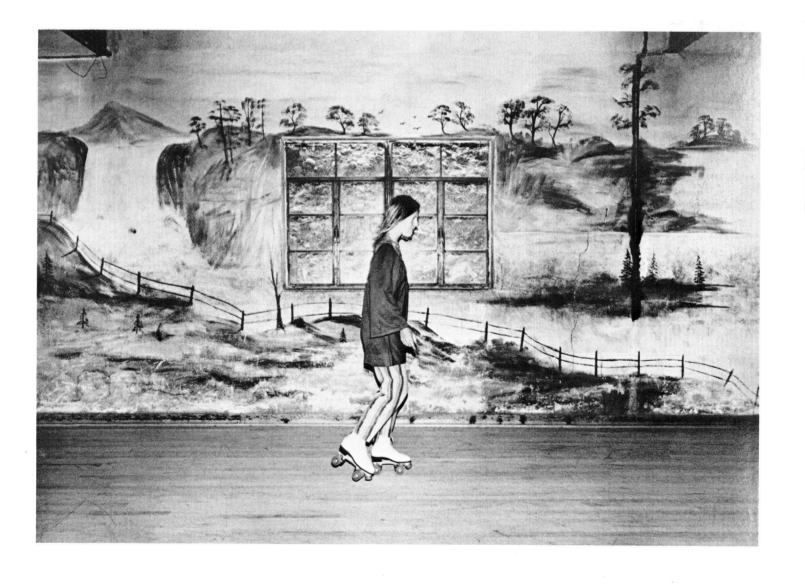

Ikko Two Ladies with Identical Jackie
Kennedy Masks, New York. 1970

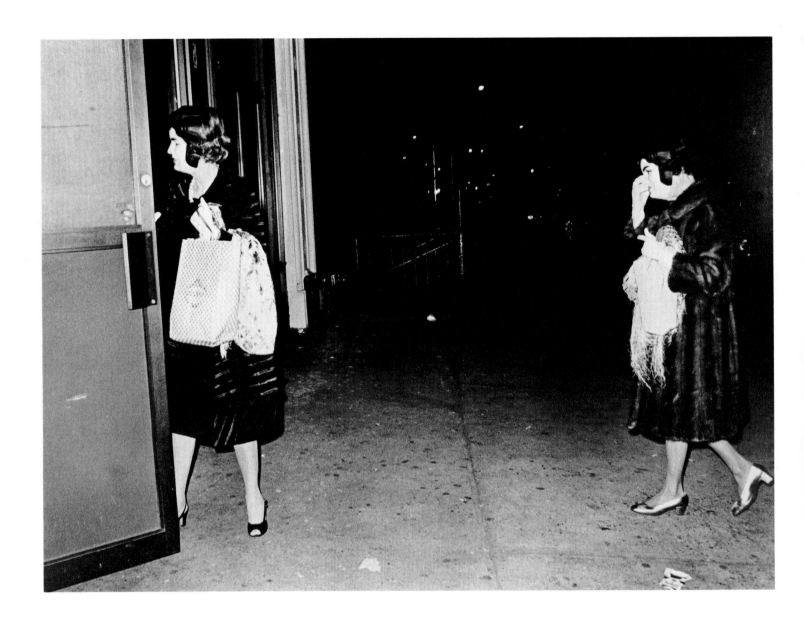

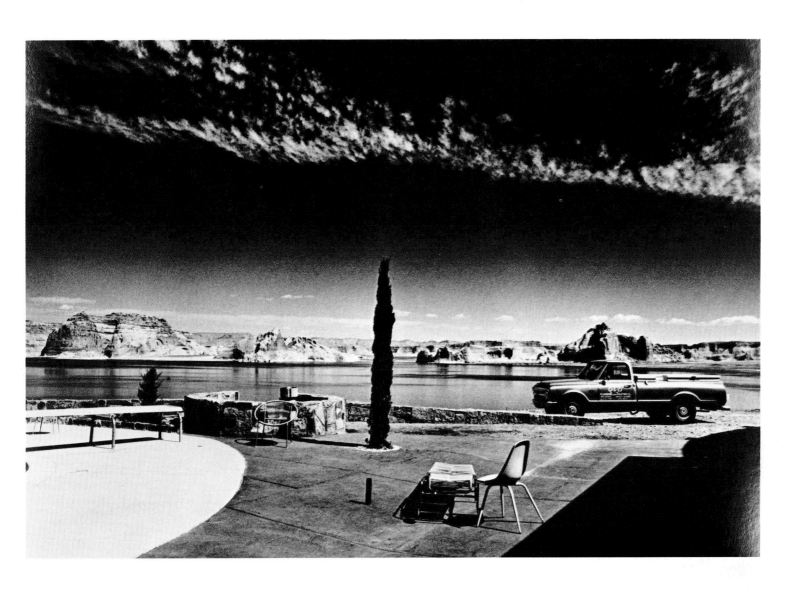

Ikko
Two Garbage Cans, Indian Village,
New Mexico. 1972

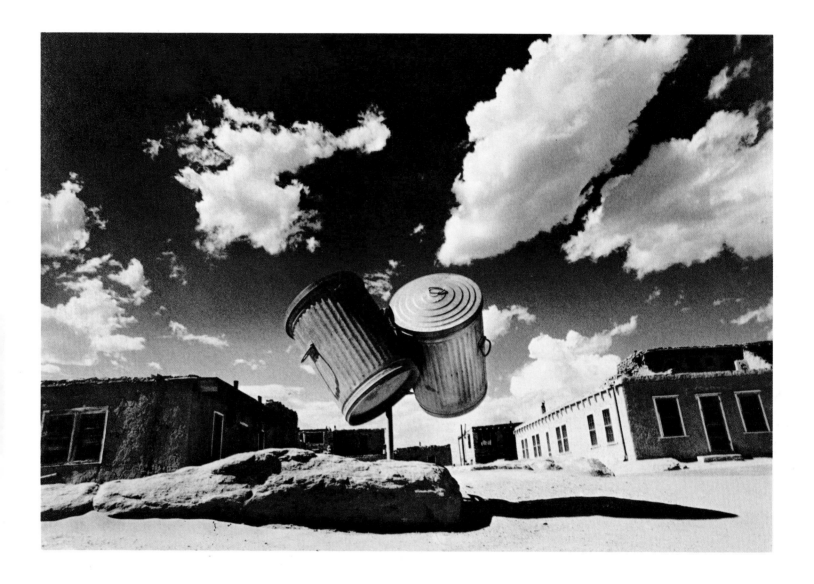

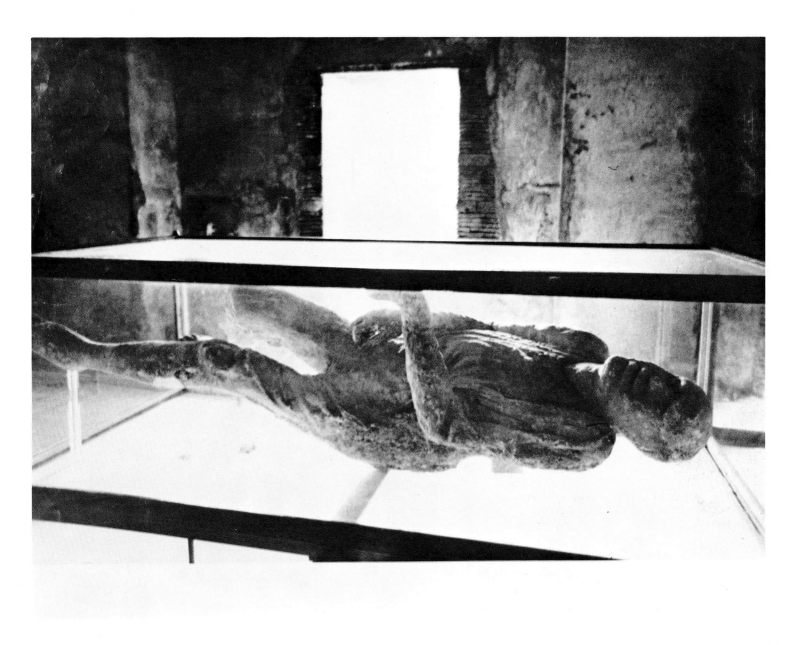

Eikoh Hosoe

From *Killed by Roses* (1963).
Lent by Light Gallery

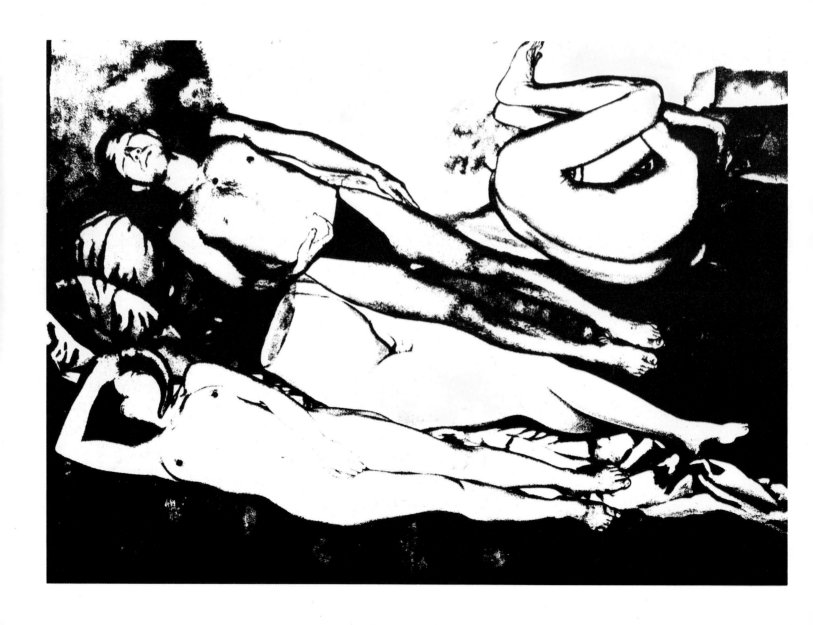

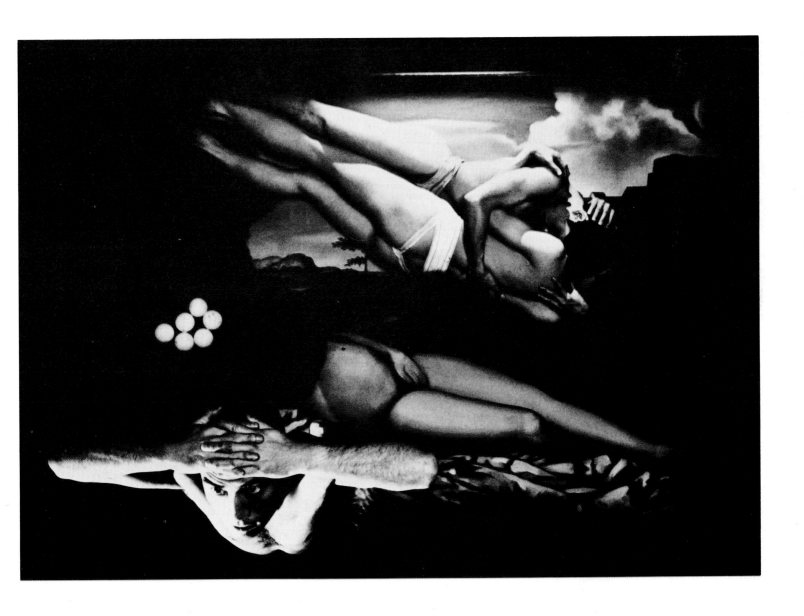

From *Killed by Roses* (1963).
Lent by Light Gallery

Eikoh Hosoe

From *Man and Woman* (1961).
Lent by Light Gallery

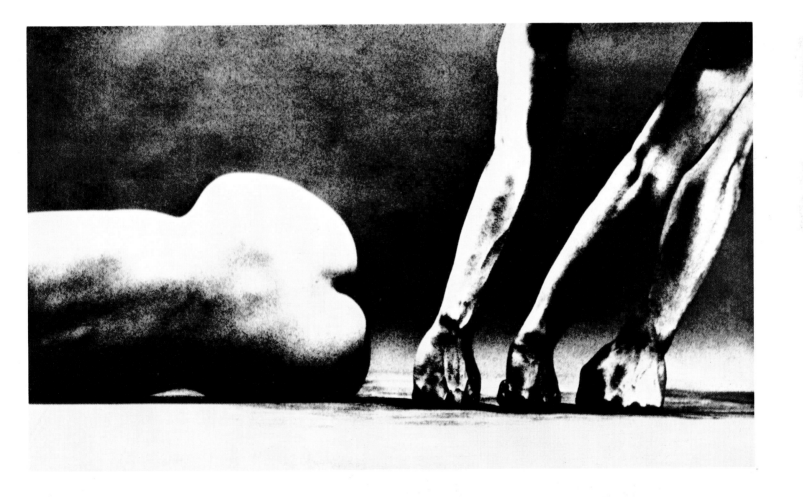

Daidoh Moriyama Entertainer on Stage, Shimizu. 1967.
From *Nippon Theater* (1968).

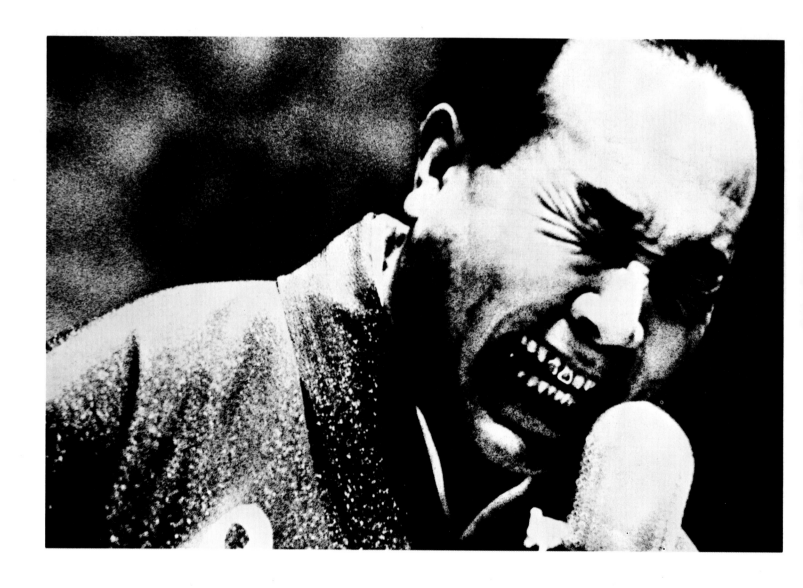

Stray Dog, Misawa. 1971. From
A Hunter (1972).

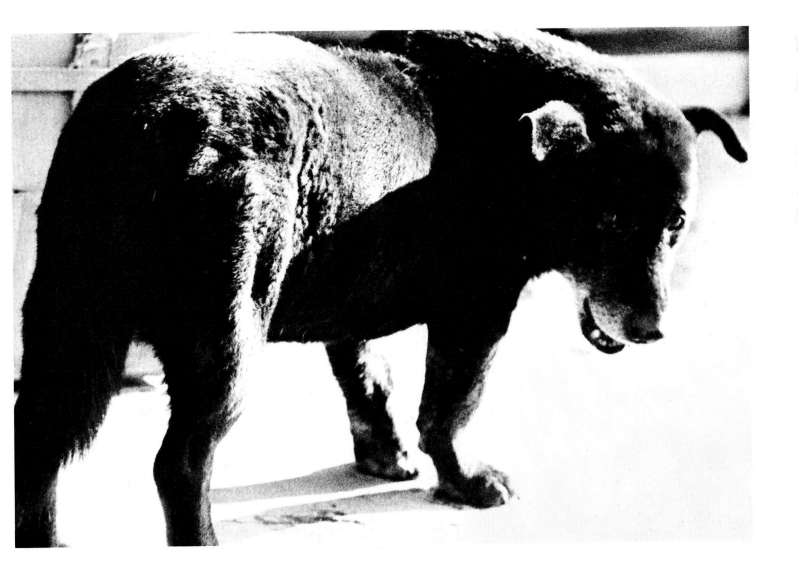

Daidoh Moriyama
Ferryboats, Tsugaru Strait. 1971.
From *A Hunter* (1972)

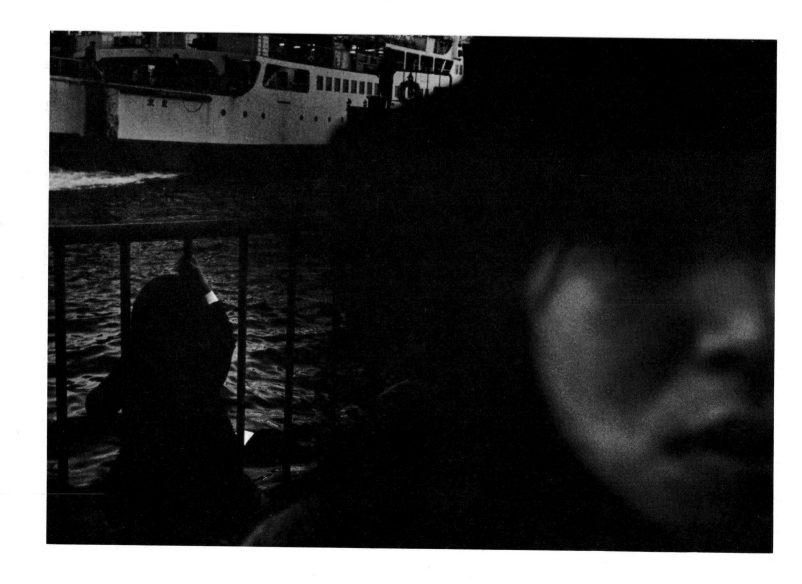

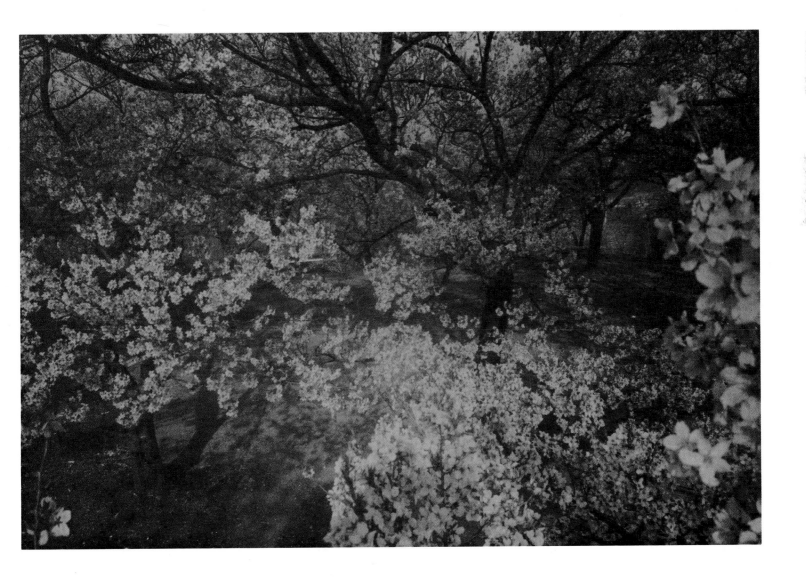

Daidoh Moriyama Soldiers, Hamamatsu. 1968. From
 A Hunter (1972)

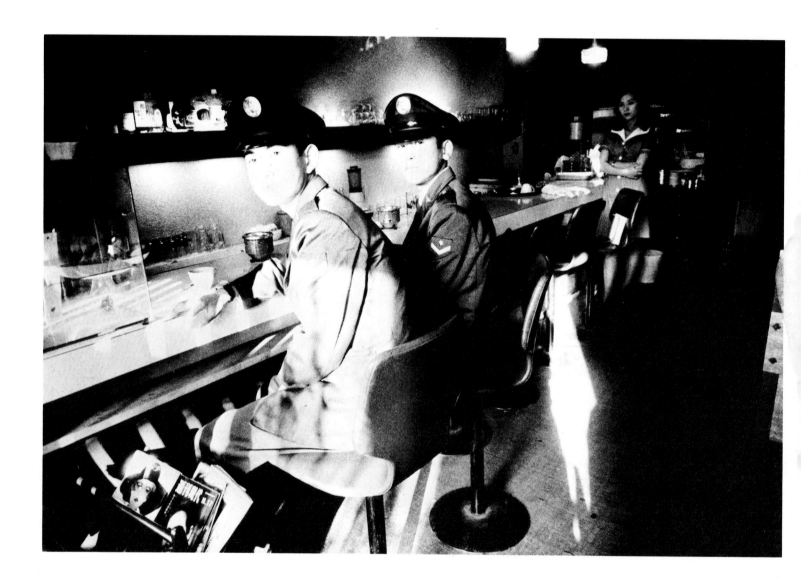

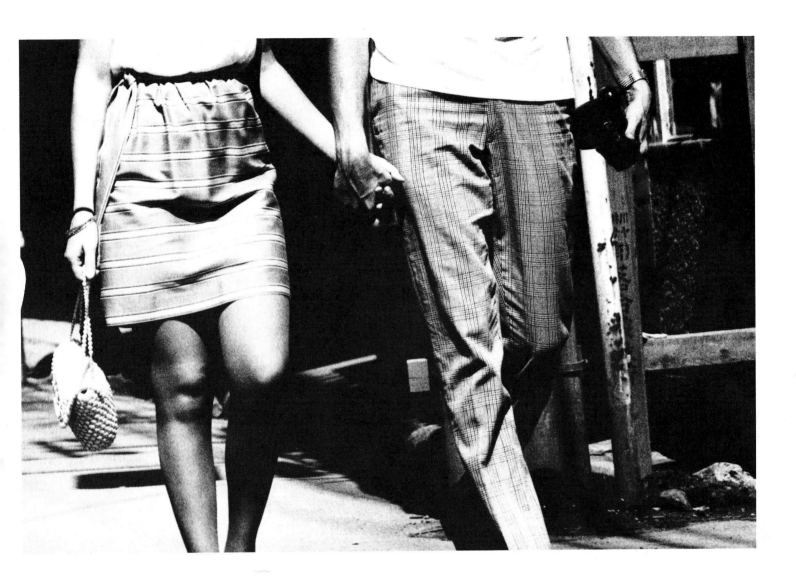

Daidoh Moriyama

Crippled Beggar, Tokyo. 1965. From
Nippon Theater (1968)

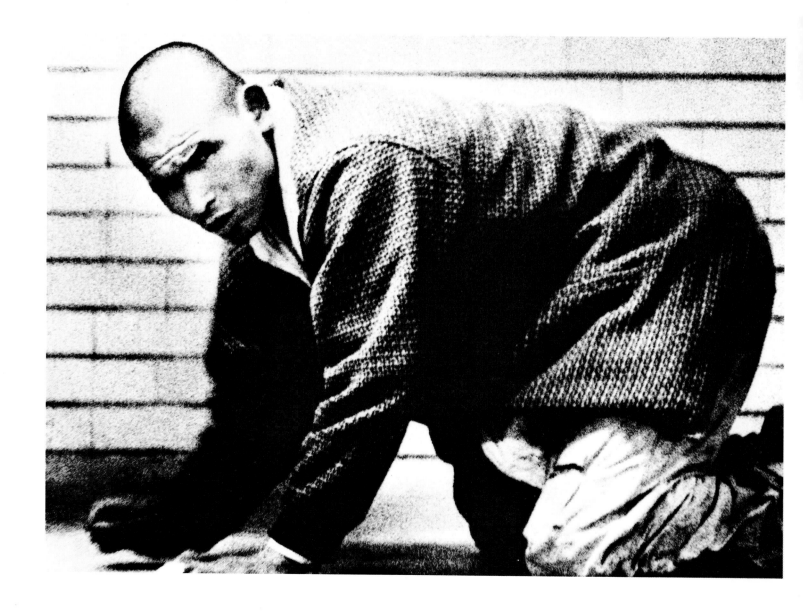

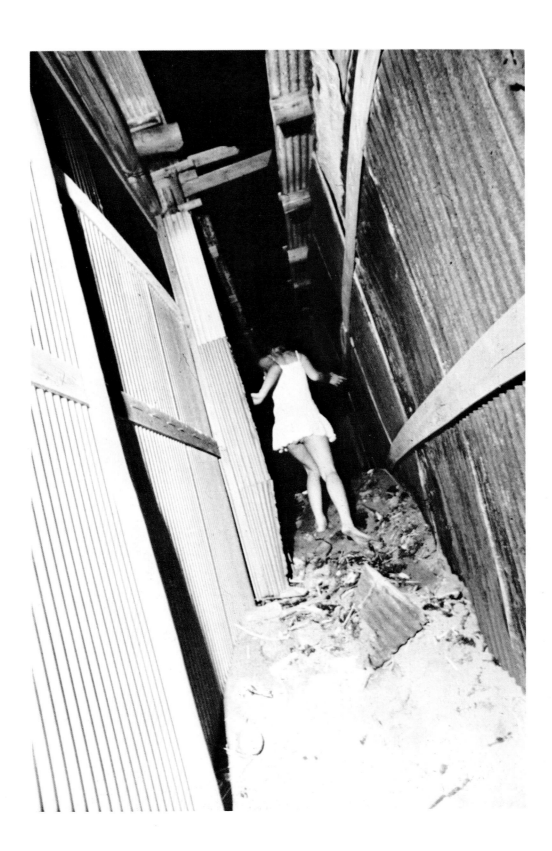

Daidoh Moriyama

Gambling in the Dressing Room,
Tokyo. 1966. From *Nippon Theater*
(1968)

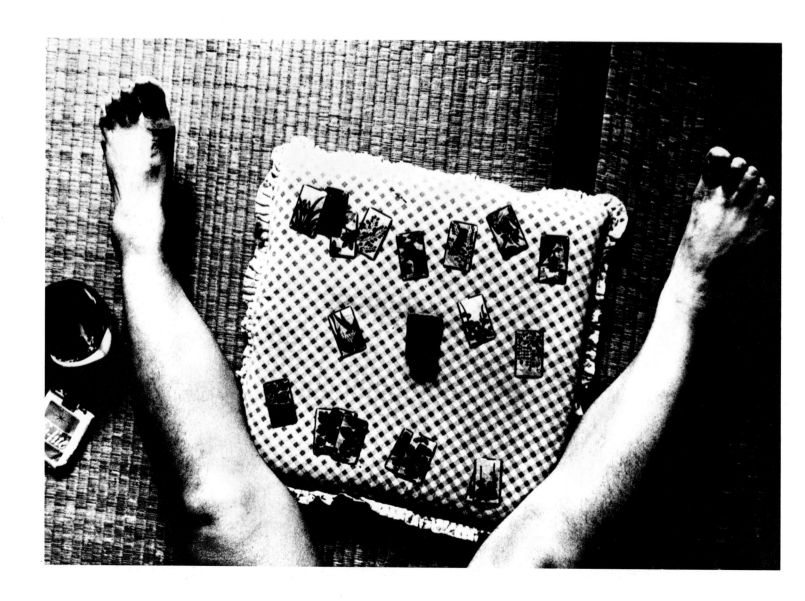

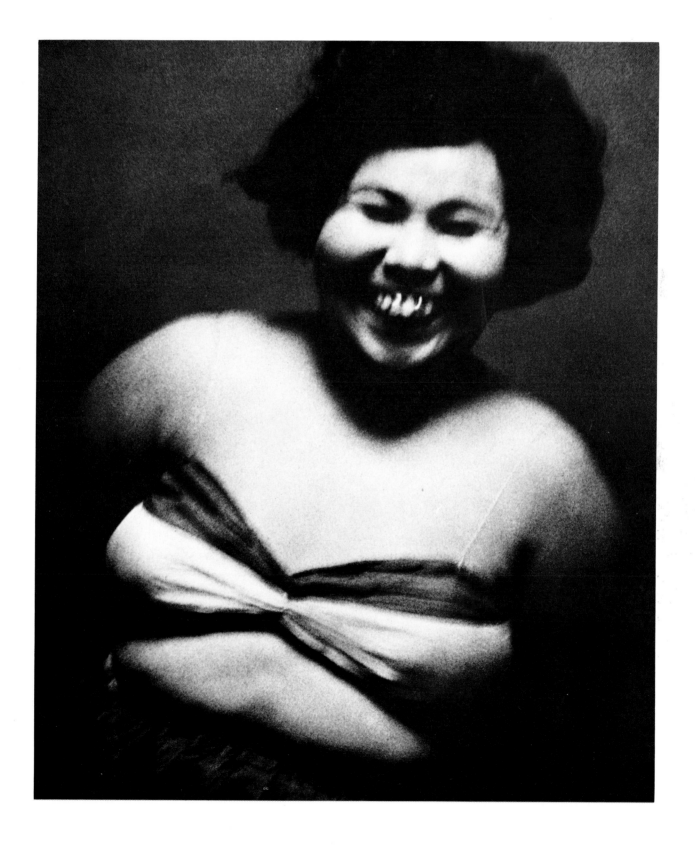

Ryoji Akiyama	Tourists Being Photographed in
front of a Torii, Miyajima. 1970

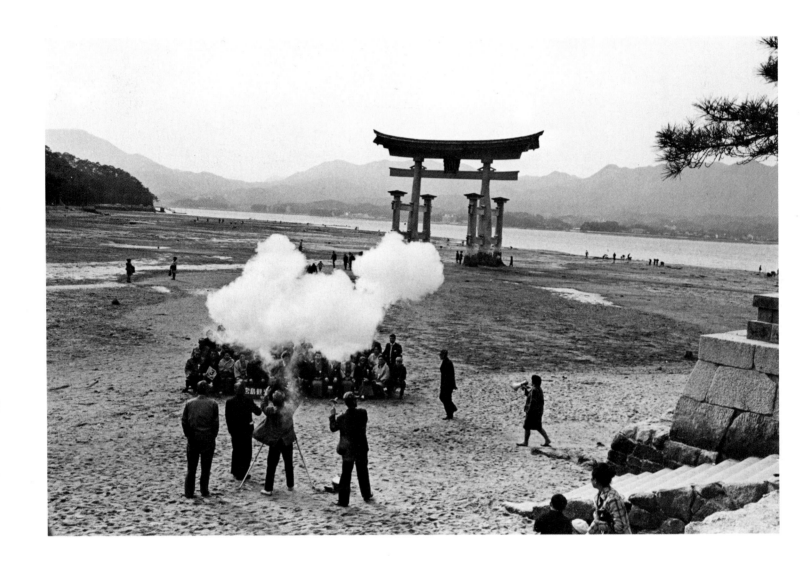

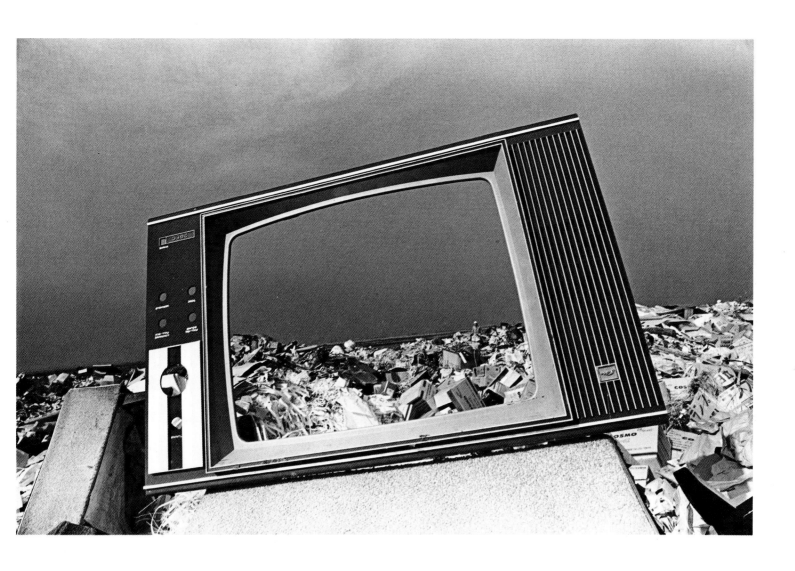

TV Frame Left in a Reclamation
Area, Tokyo. 1969

Ryoji Akiyama

Newlyweds after Planting Memorial
Trees on the Slope of a Mountain,
Kagoshima. 1970

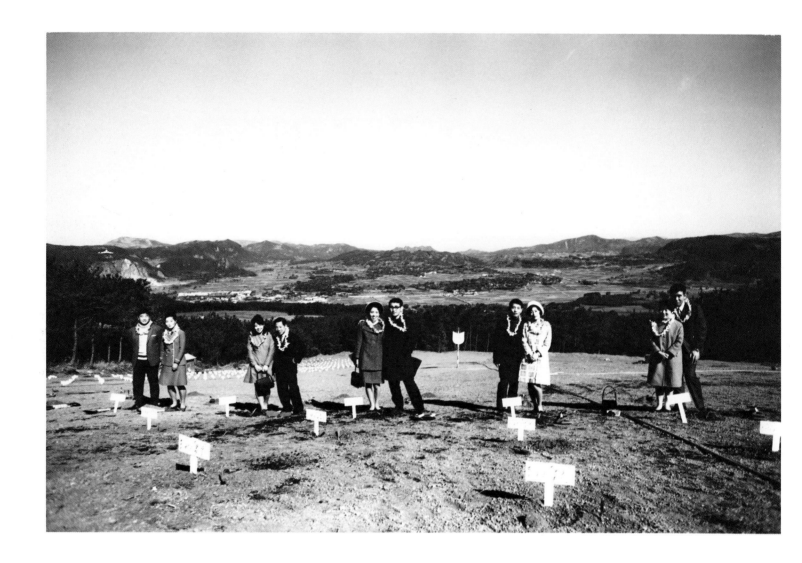

Two Men Dumping Factory Waste
onto a Junk Pile, Tokyo Bay. 1969

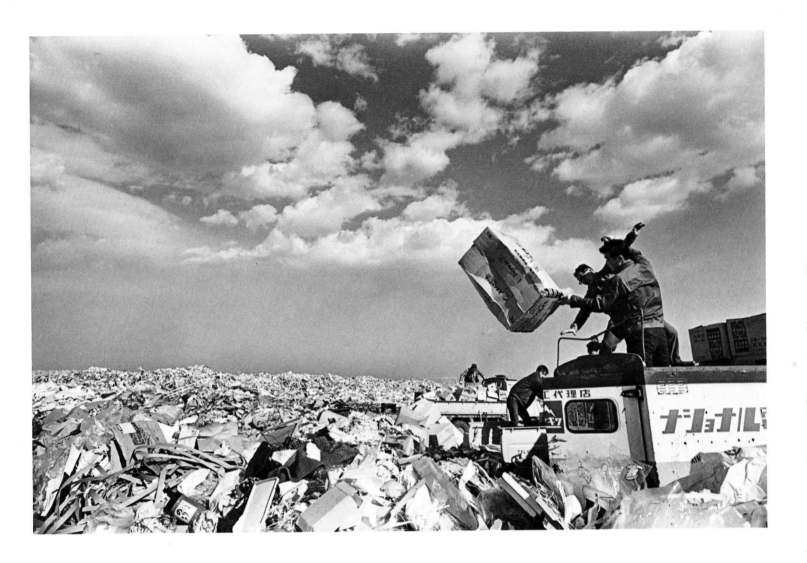

97

Ryoji Akiyama

Empty Box on Its Way Down to a
Reclamation Area, Tokyo. 1969

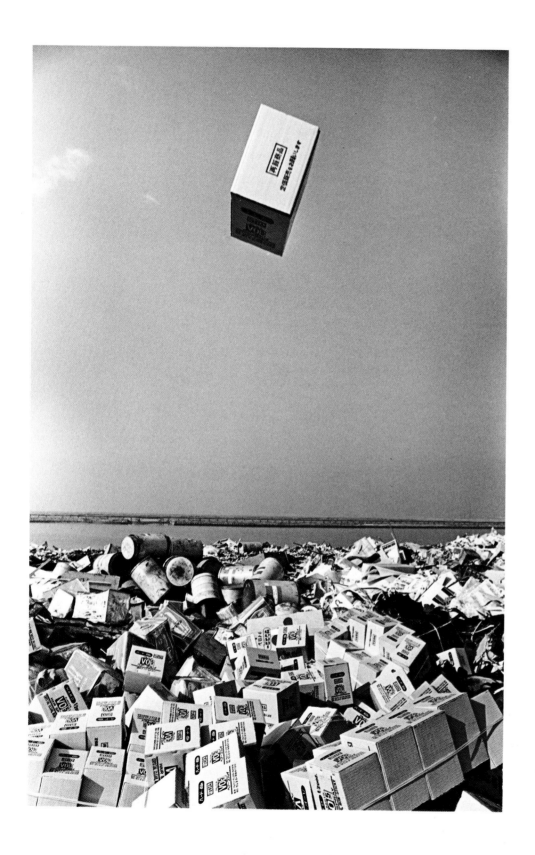

Old Lobster Fisherman, Tokyo.
1968

Ken Ohara From *One* (1970) ▷

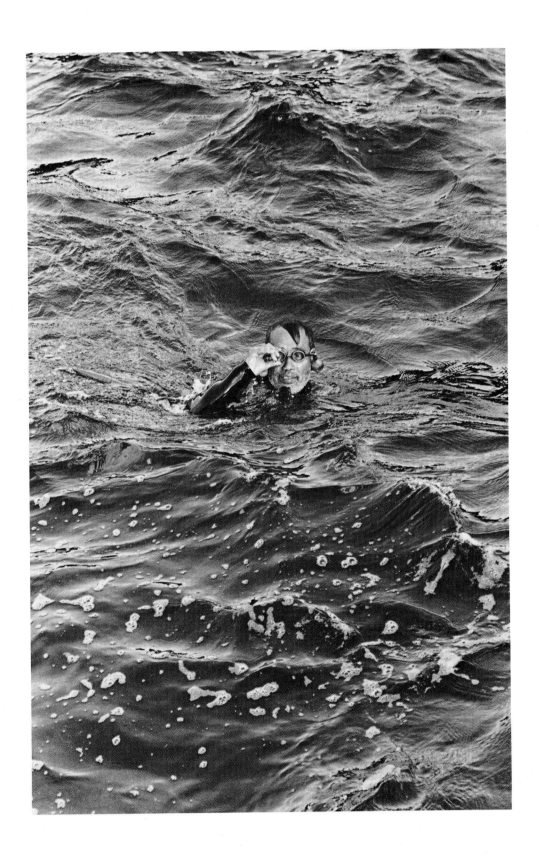

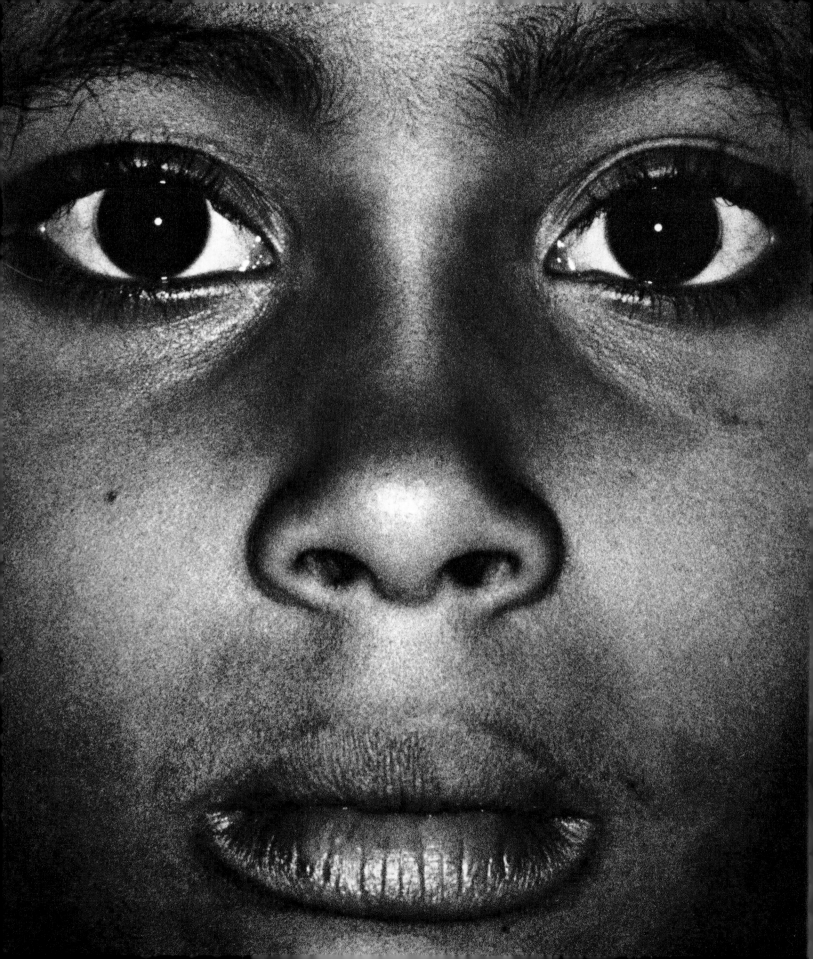

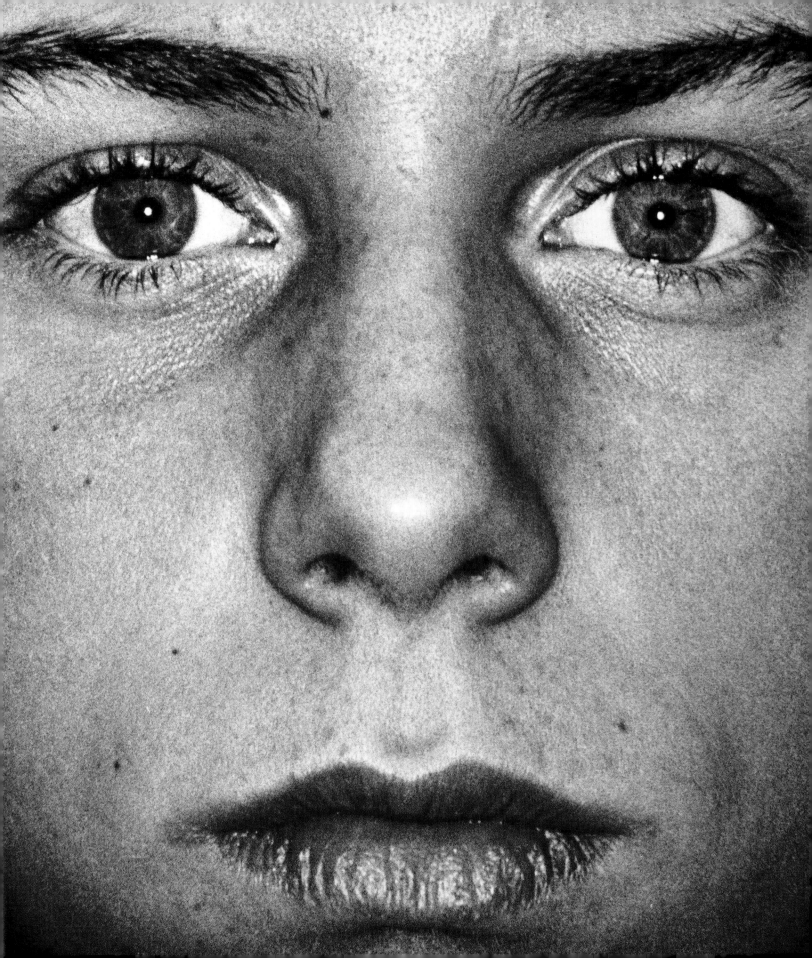

Shigeru Tamura

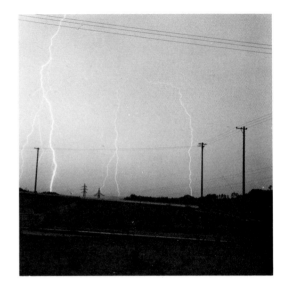

July 18, 1967

October 8, 1967

October 24, 1967

December 24, 1967

February 16, 1968

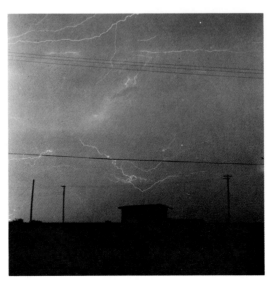

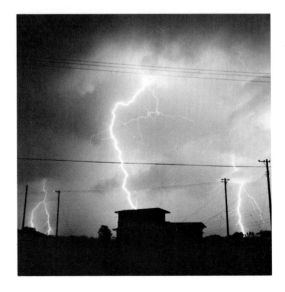

June 19, 1968

June 22, 1968

July 6, 1968

July 27, 1968

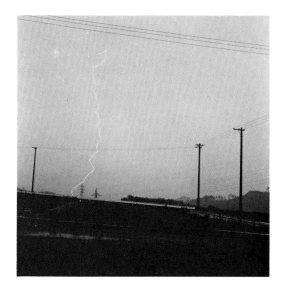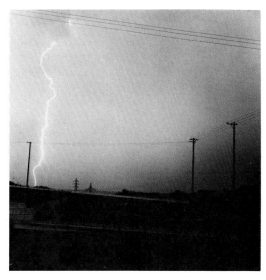

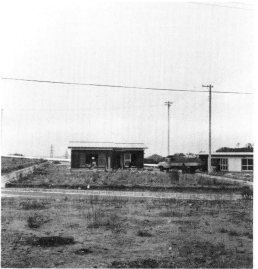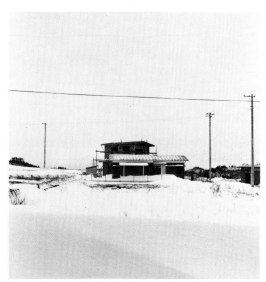

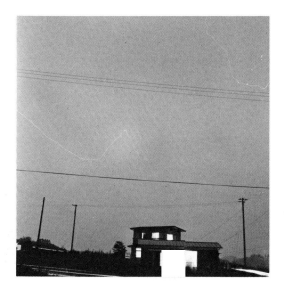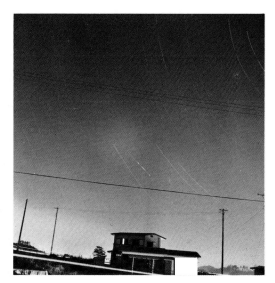

1194 Imaizumi, Kamakura, Kanagawa-ken. —From a summer evening one year to a summer evening the next year—

Bishin Jumonji Untitled. 1973

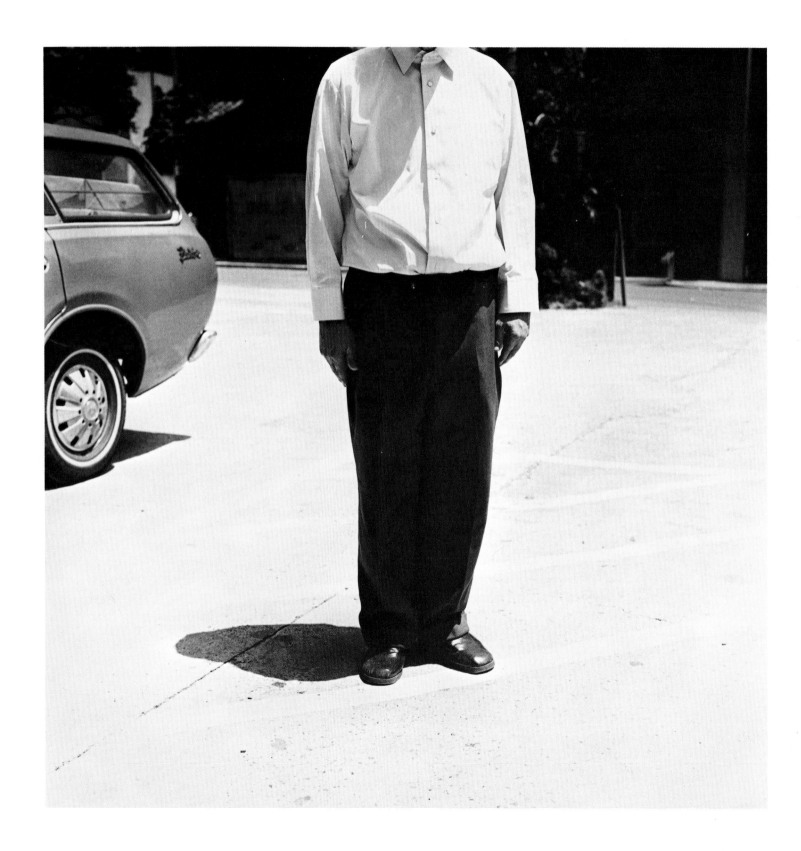

Biographical Notes

Unless another location is indicated, the exhibitions and the publications cited were produced in Tokyo.

Ken Domon

photo Shigekazu Nagano

Born 1909 in Yamagata. In 1932, Domon was expelled from Nihon University where he was a law student, after his arrest for involvement in a radical farmers' movement. The next year he was given an apprenticeship by Kotaro Miyauchi Photo Studio, and two years later he joined Nihon Kobo, a photo agency. In 1945 he turned to free-lance work, and since then has been known as one of the nation's leading photographers, advancing the spirit of objectivity in Japanese photography. Domon suffered apoplectic strokes in 1960 and 1968, but despite this handicap he has continued to devote himself to documenting Japan's traditional arts.

His books include such journalistic works as *Hiroshima* (Kenkoh-sha, 1958), *Children of Chikuho Coal Mines* (Patoria-shoten, 1960), and *Rumie's Daddy Is Dead* (Kenkoh-sha, 1960), as well as a collection of portraits entitled *Fubo* (Ars, 1953). In addition, he has extensively covered the traditional arts, publishing *The Muro-ji* (Bijutsu-shuppan-sha, 1954), *Pilgrimages to Ancient Temples* (in four volumes, Bijutsushuppan-sha, 1963–71), *Taishi-no-Midera—The To-ji* (Bijut-

sushuppan-sha, 1965), *Bunraku* (Shinshindo, Osaka, 1972), *The Todai-ji* (Heibon-sha, 1973), and more than ten others.

Domon has had five one-man exhibitions: "Children of Downtown Tokyo" (Takashimaya, 1955), "Children of Chikuho Coal Mines" (Fuji-Photo Salon, 1960), "Days of Hatred and Disappointment—Hiroshima" (Ginza Nikon Salon, 1968), "Pilgrimages to Ancient Temples" (Odakyu Department Store, 1972), and "Bunraku" (Wako Gallery, 1973).

Prizes and awards won include: Mainichi Photography Award (1958); The Photographer of the Year Award of Japan Photo Critics Association (1958); The Minister of Education Award of Arts (1959); Photographic Society of Japan Award (1960); Japan Journalists Congress Award (1960); Grand Prix of the International Exhibition of News Photographs at The Hague (1960); Mainichi Art Award (1961); The Kan Kikuchi Award (1971).

Yasuhiro Ishimoto

photo Hiroaki Tanaka

Born 1921 in San Francisco, California. Ishimoto spent part of his childhood (1924–39) in Kochi, Japan, the native town of his parents. He returned to California in 1939 and two years later entered the University of California. World War II broke out and in 1942 he was sent to a relocation camp in Amach, Colorado, where he learned photography. After the war, Ishimoto studied with Harry Callahan and Aaron Siskind in the Photography Department of the Chicago Institute of Design, from which he graduated in 1952. In 1953, when he went back to Japan for a five-year stay, Ishimoto began photographing the Katsura Palace in Kyoto. He revisited Chicago in 1958, but in 1961 he again returned to Japan to continue his work and teach at the Tokyo Institute of Photography and the Tokyo University of Formative Arts. In 1969 he obtained Japanese citizenship.

His major books include *Someday, Somewhere* (Geibi-sha, 1958), *Katsura* (Yale University Press, New Haven, 1960), *Chicago, Chicago* (Bijutsushuppan-sha, 1969), and *Tokyo* (Chuokoron-sha, 1971).

He has twice exhibited at The Museum of Modern Art in New York

(1953, 1961) and had one-man exhibitions in Tokyo (Takemiya Gallery, 1954, and Shirokiya, 1962), and at the Art Institute of Chicago (1960).

Prizes and awards won include: Moholy-Nagy Prize (1951); The Most Promising Photographer Award of Japan Photo Critics Association (1958); Mainichi Art Award (1970).

Shomei Tomatsu

Kikuji Kawada

photo Shoji Yamagishi

self-portrait

Born 1930 in Nagoya. Tomatsu joined the staff of Iwanami Shashin Bunko upon graduation from the Economics Department of Aichi University in 1954. Two years later he became a free-lance photographer. Tomatsu was a coauthor, with Ken Domon and others, of *Hiroshima-Nagasaki Document '61,* which was published in 1961 by the Japan Conference for Banning the A-Bomb. In 1964 he traveled to Afghanistan, and in 1972–73 he visited Okinawa when the islands were being returned to Japanese rule. Tomatsu has made the dramatically changing society of modern Japan his subject matter.

His books include *11:02—Nagasaki* (Shashindohjin-sha, 1966), *Nippon* (Shaken, 1967), *Salaam Aleikoum* (Shaken, 1968), *Okinawa* (Shaken, 1969), *Oh Shinjuku!* (Shaken, 1969), *Après-Guerre* (Chuokoron-sha, 1971), and *I Am a King* (Shashinhyoron-sha, 1972).

He has had three one-man exhibitions: "The Japanese" (Fuji-Photo Salon, 1959), "11:02—Nagasaki" (Fuji-Photo Salon, 1962), "Kingdom of Mud" (Fuji-Photo Salon, 1964).

Awards won include: The Most Promising Photographer Award of Japan Photo Critics Association (1958); Mainichi Photography Award (1959); The Photographer of the Year Award of Japan Photo Critics Association (1961).

Born 1933 in Ibaragi. Kawada graduated from the Economics Department of Rikkio University in 1956. After working for Shincho-sha as a staff photographer, he turned free-lance in 1959. In 1966 he made a tour of Europe, and in 1968 he visited both Europe and Southeast Asia. The trips resulted in a collection of photographs that explored the aesthetic of the grotesque. Kawada is not a prolific photographer, but he has worked steadily, following his own direction.

His books include *The Map* (Bijut-sushuppan-sha, 1965) and *Sacré Atavism* (Shashinhyoron-sha, 1971).

He has had three one-man exhibitions: "The Sea" (Fuji-Photo Salon, 1959), "The Map" (Fuji-Photo Salon, 1962), and "Sacré Atavism" (Ginza Nikon Salon, 1968).

Masatoshi Naitoh **Tetsuya Ichimura** **Hiromi Tsuchida**

photo Shiro Tatumi

self-portrait

Born 1938 in Tokyo. Naitoh received a B.S. in 1961 from Waseda University. He started taking photographs while studying there. After working one year in industry as a chemical engineer, he abandoned his profession to become a free-lance photographer. Naitoh has a keen interest in the representation of folklore, and is a member of the Folklore Society of Japan.

He has written and published two books on folklore: *Mummies in Japan* (Kohfuh-sha, 1969) and *Structure of Courtesy* (Kohseishuppan-sha, 1972).

His one-man exhibitions include: "Z.A.Z." (Gekko Gallery, 1963); "Mummies in Japan" (Shirokiya, 1966); "Homunculus" (Gallery Crystal, 1966); "Hags" (Ginza Nikon Salon, 1970); "Photos of Carnival Shows on Exhibit at Carnival Sites" (Tokyo and other cities and towns in Japan, 1970); and "Touring Photo Exhibition on the Farmer's Campaign against the New Airport Project at Heta, Sanrizuka" (1973).

Winner of The Most Promising Photographer Award of Japan Photo Critics Association (1966).

Born 1930 in Nagasaki. After studying briefly at Nihon University, Ichimura held more than a dozen jobs. His winning of a special award in 1956 at the First International Subjectivism Photo Exhibition encouraged him to become a free-lance photographer. His photographs express a somber view of eroticism.

His books include *Salome* (Gendai-shinsha, 1970) and *Come Up* (Shashinhyoron-sha, 1971).

He has had two one-man exhibitions: "Love and Lost" (Fuji-Photo Salon, 1963) and "Nagasaki" (Canon Salon, 1973).

Born 1939 in Fukui. Tsuchida graduated from the Technology Department of Fukui University in 1963 and the Tokyo Institute of Photography in 1965. After working for the advertising department of a cosmetics manufacturer, he turned free-lance in 1971. His photographs on what is basic and unsophisticated in the Japanese people have an aura of the old-fashioned which is uniquely his own.

He has had two one-man exhibitions: "Black Rhapsody" (Shizuoka, 1964) and "An Autistic Space" (Ginza Nikon Salon, 1971).

Winner of the Taiyo Award (1970).

Masahisa Fukase　　　Ikko

photo Ikko Nozawa

photo Keiko Narahara

Born 1934 in Hokkaido. Fukase graduated from the Photography Department of Nihon University in 1956. He worked as a staff photographer for advertising and publishing companies until 1968, when he turned free-lance. During the past decade, Fukase has drawn on his own life for his photographic subject matter.

He has published the book *Homo Ludence* (Chuokoron-sha, 1971).

He has had two one-man exhibitions: "Sky over an Oil Refinery" (Konishiroku Gallery, 1960) and "A Slaughterhouse" (Ginza Gallery, 1961).

Born 1931 in Fukuoka. Ikko, whose full name is Ikko Narahara, received a law degree from Chuo University in 1954 and an M.A. in Art History from Waseda University in 1959. He began his career as a free-lance photographer in 1956 after his first one-man exhibition. Since then, Ikko has worked primarily with the photo-essay form, but he has also been active in movies, environmental art, and happenings. He lived in Europe from 1962 to 1965, and in New York from 1970 to 1974.

His books include: *Where Time Has Stopped* (Kajima Shuppankai, 1967); *The World of Kazuo Yagi* (Kyuryudo, 1969); *España Gran Tarde* (Kyuryudo, 1969); *Japanesque* (Mainichi Newspapers, 1970); *Europe* (portfolio, Chikuma-shobo, 1971); *Man and His Land* (Chuokoron-sha, 1971); and *Celebration of Life* (Mainichi Newspapers, 1972).

He has had nine one-man exhibitions in Japan: "Man and His Land" (Matsushima Gallery, 1956); "His Territory" (Fuji-Photo Salon, 1958); "His Territory" (Fuji-Photo Salon, Osaka, 1959); "Image of Castle" (Marunouchi Gallery, 1959); "Blue Yokohoma" (Gekko Gallery, 1960); "Land of Chaos" (Fuji-Photo Salon, 1960); "España Gran Tarde" (Fuji-

Photo Salon, 1965); "España Gran Tarde" (Seibu Ikebukuro, 1970); "Celebration of Life" (Seibu Shibuya, 1972). In addition, Ikko has had three one-man shows in the United States, all in 1973—at Neikrug Gallery and Nikon House, both in New York City, and at the International Museum of Photography, George Eastman House, Rochester, New York.

Awards won include: The Most Promising Photographer Award of Japan Photo Critics Association (1958); The Minister of Education Award of Arts (1967); The Photographer of the Year Award of Japan Photo Critics Association (1967); Mainichi Art Award (1967).

Eikoh Hosoe

Daidoh Moriyama

Ryoji Akiyama

photo © Allen A. Dutton

photo Ruy Yokoyama

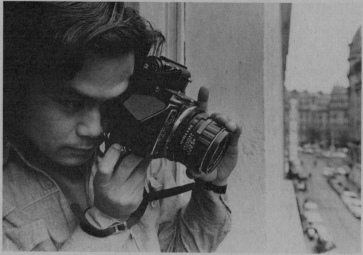

photo Seiki Kobayashi

Born 1933 in Yamagata. After graduating from the Tokyo College of Photography in 1954, Hosoe became a free-lance photographer. In 1959 he organized, with Shomei Tomatsu, Kikuji Kawada, Ikko, and others, a group called VIVO, in response to the challenge of new photographic ideas. Hosoe is internationally the most active of the Japanese photographers.

His books include *Man and Woman* (Camerart, 1961), *Killed by Roses* (Shuei-sha, 1963), *Kamaitachi* (Gendaishicho-sha, 1969), *Embrace* (Shashinhyoron-sha, 1971), and *Ordeal by Roses* (Shuei-sha, 1971).

One-man exhibitions held in Japan include: "An American Girl in Tokyo" (Konishiroku Gallery, 1956); "Man and Woman" (Konishiroku Gallery, 1960); "Photo Exhibition Dedicated to Dancer Tatsumi Hijikata" (Gekko Gallery, 1960); "An Extravagantly Tragic Comedy" (Ginza Nikon Salon, 1968); and "Eikoh Hosoe" (Gallery Shunjuh, 1971). He has also had shows at the Smithsonian Institution, Washington, D.C. (1969), Focus Gallery, New York (1969), Phoenix College, Arizona (1970), the Visual Studies Workshop, *(continued, bottom of column 3)*

Born 1938 in Osaka. Upon completion of the design course at the Osaka Municipal High School of Industrial Arts in 1958, Moriyama became a free-lance commercial designer. However, increasing interest in photography caused him to abandon that career and study with Takeji Iwamiya (1960) and Eikoh Hosoe (1961–63). In 1963 he became a free-lance photographer. Moriyama is extremely popular among younger Japanese photographers.

His books include *Nippon Theater* (Muromachi-shobo, 1968), *Farewell to Photography* (Shashinhyoron-sha, 1972), and *A Hunter* (Chuokoron-sha, 1972). He started publishing his own series entitled "Document" in 1972, with six volumes published to date.

He has had a one-man show called "Scandal" (Plaza Dick, 1970), the material of which was taken from billboards and advertisements for sensational magazines.

Winner of The Most Promising Photographer Award of Japan Photo Critics Association (1967).

Born 1942 in Tokyo. Akiyama graduated from the Department of Literature, Waseda University, in 1964. He began his career as a staff photographer for the Asahi Newspapers and the Associated Press in Tokyo, but turned to free-lance work in 1967.

(Eikoh Hosoe, continued)
Rochester, New York (1972), and Light Gallery, New York (1973). In 1973 he taught workshops at Phoenix College, Arizona, and Columbia College, Chicago, Illinois.

Awards won include: The Most Promising Photographer Award of Japan Photo Critics Association (1960); The Photographer of the Year Award of Japan Photo Critics Association (1963); The Minister of Education Award of Arts (1970).

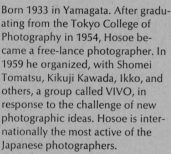

Ken Ohara Shigeru Tamura Bishin Jumonji

self-portrait

photo Tadayuki Kawahito

Born 1942 in Tokyo. Ohara came to New York in 1962, after a brief period of study at Nihon University, and attended the Art Students League from 1963 to 1965. From 1966 to 1970, he worked as an assistant to Richard Avedon and Hiro. In 1971 he became a free-lance photographer. His projects in conceptual art have drawn considerable attention.

He has published a book entitled *One* (Tsukiji-shokan, 1970).

He has had a one-man exhibition, "365" (Asahi Pentax Gallery, 1971).

Born 1947 in Tokyo. Tamura graduated from the Tokyo Institute of Photography in 1969. He became a free-lance photographer the same year.

He has had a one-man exhibition, "A Light of Dream" (Ginza Nikon Salon, 1969).

Born 1947 in Yokohama. Jumonji graduated from Kanagawa Prefectural High School of Industry in 1965. He began working as an assistant to Kishin Shinoyama in 1969 but became free-lance in 1971. His work is primarily concerned with a close analysis of people.